Hammam Ladies

Paula Sweet

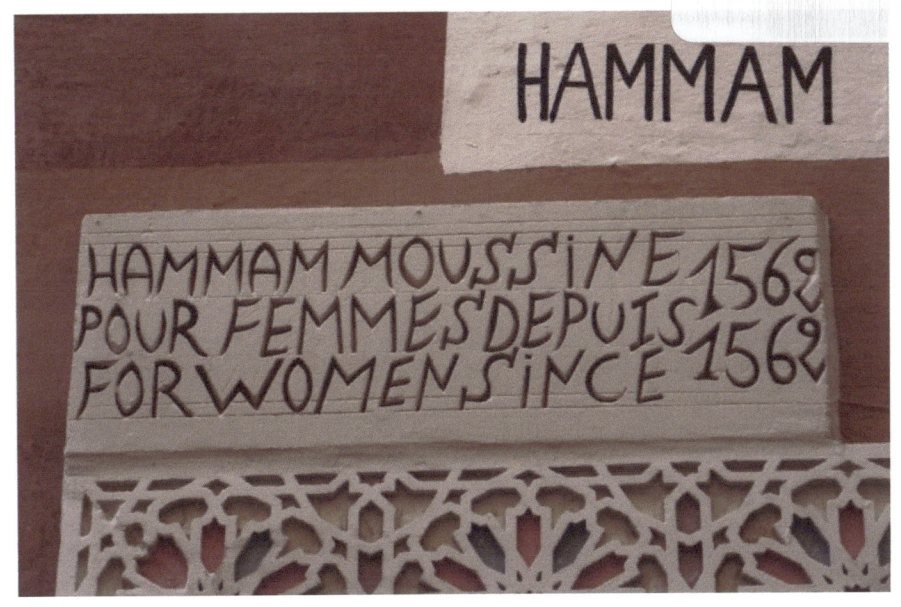

An 'HcT! book

Hammam Ladies

Photography ©2016 by Paula Sweet
ISBN 978-1533237408

First edition May 2016

Designed by SMoss

An 'HcTi' Book

This book is dedicated
to Stanley Moss
who implored me to paint what it was like inside
because he wasn't allowed in.

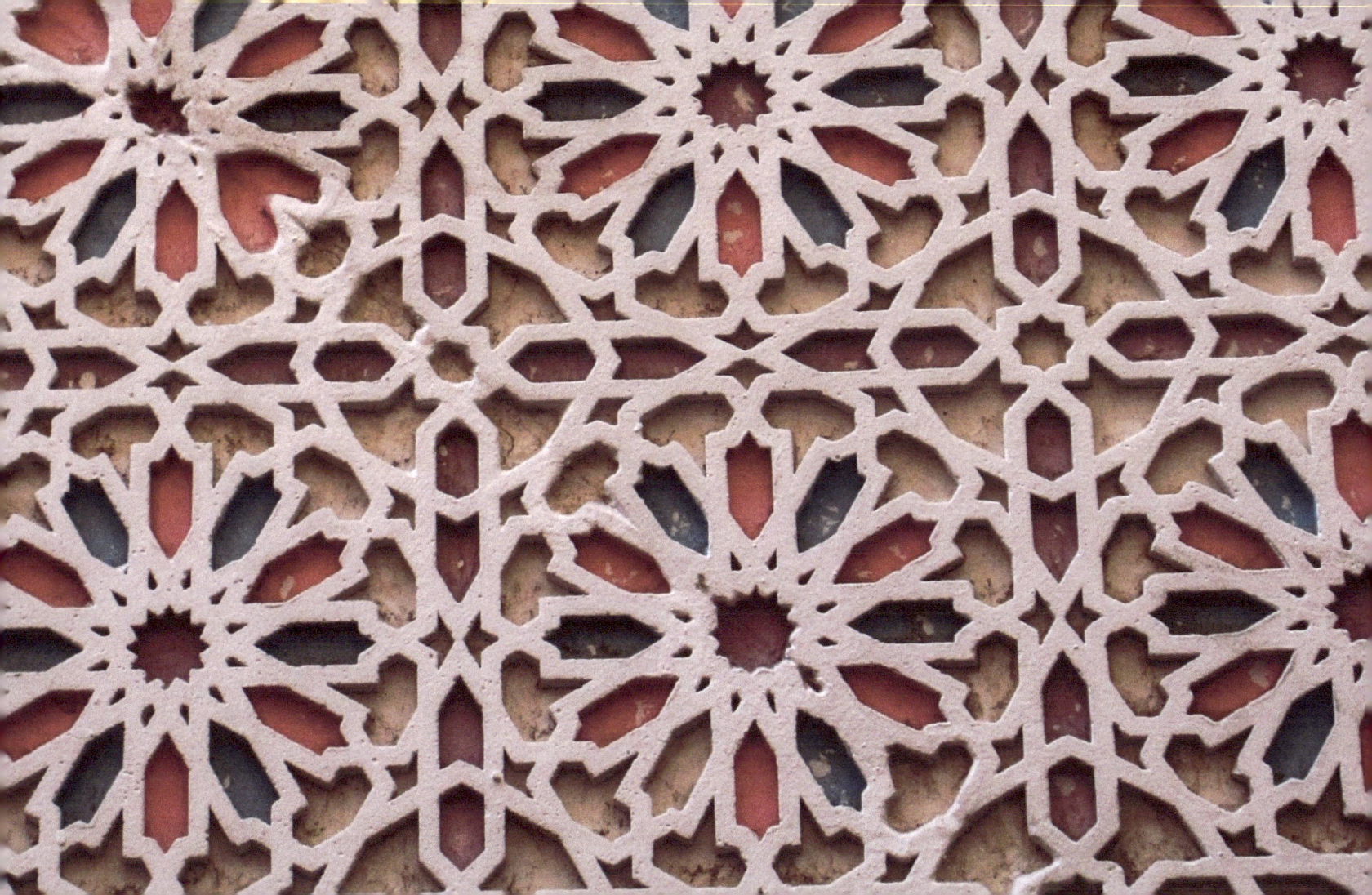

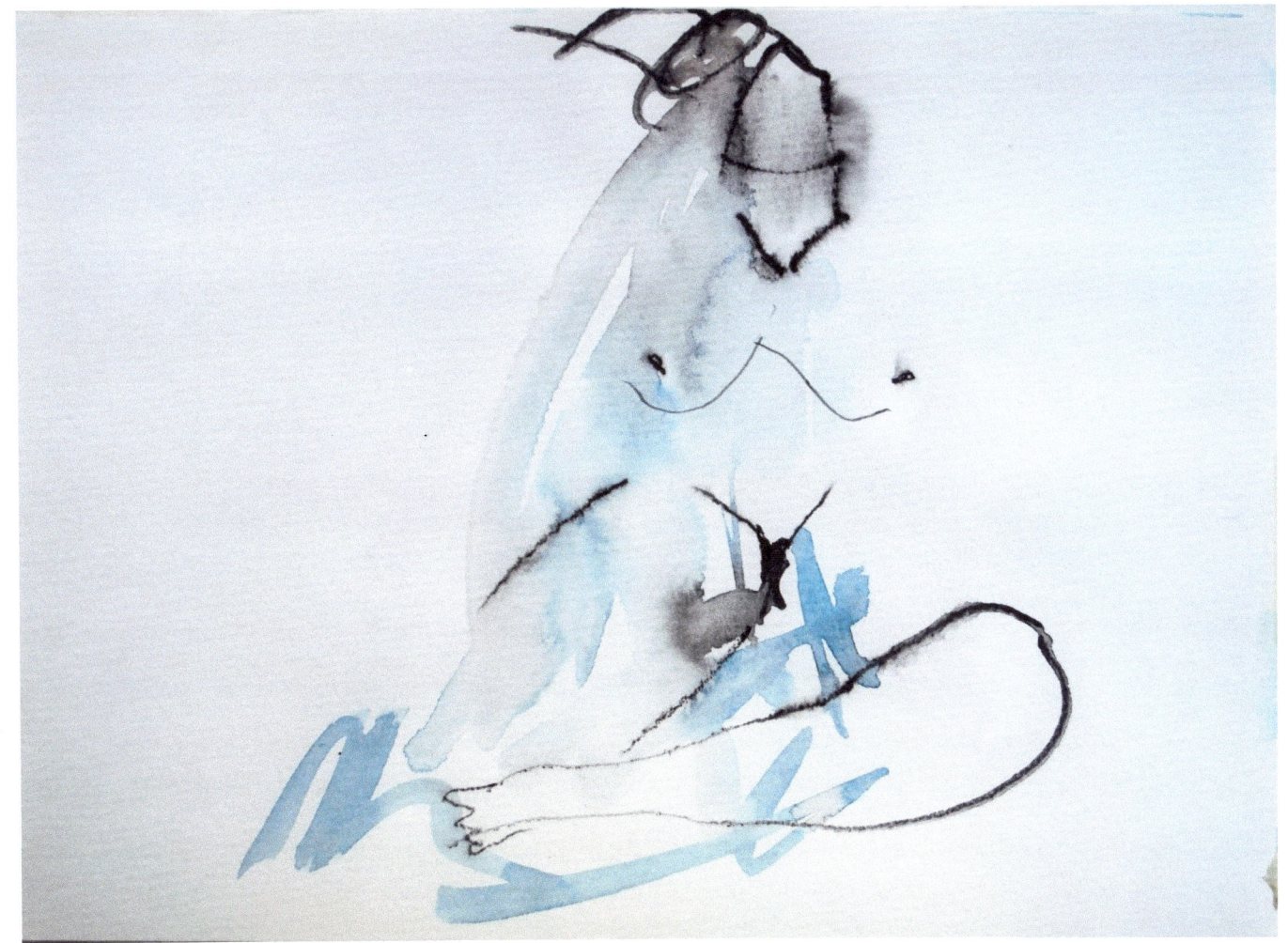

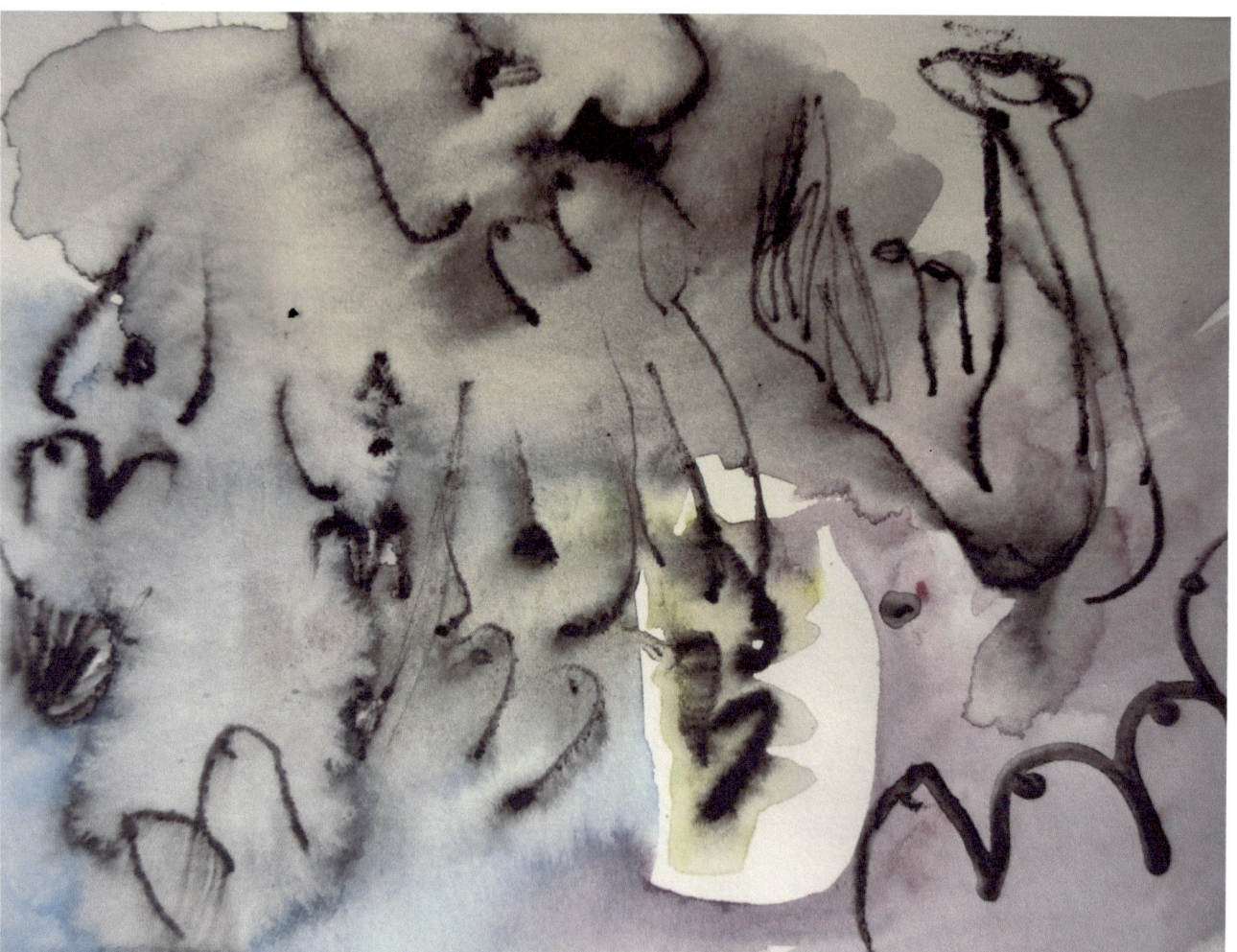

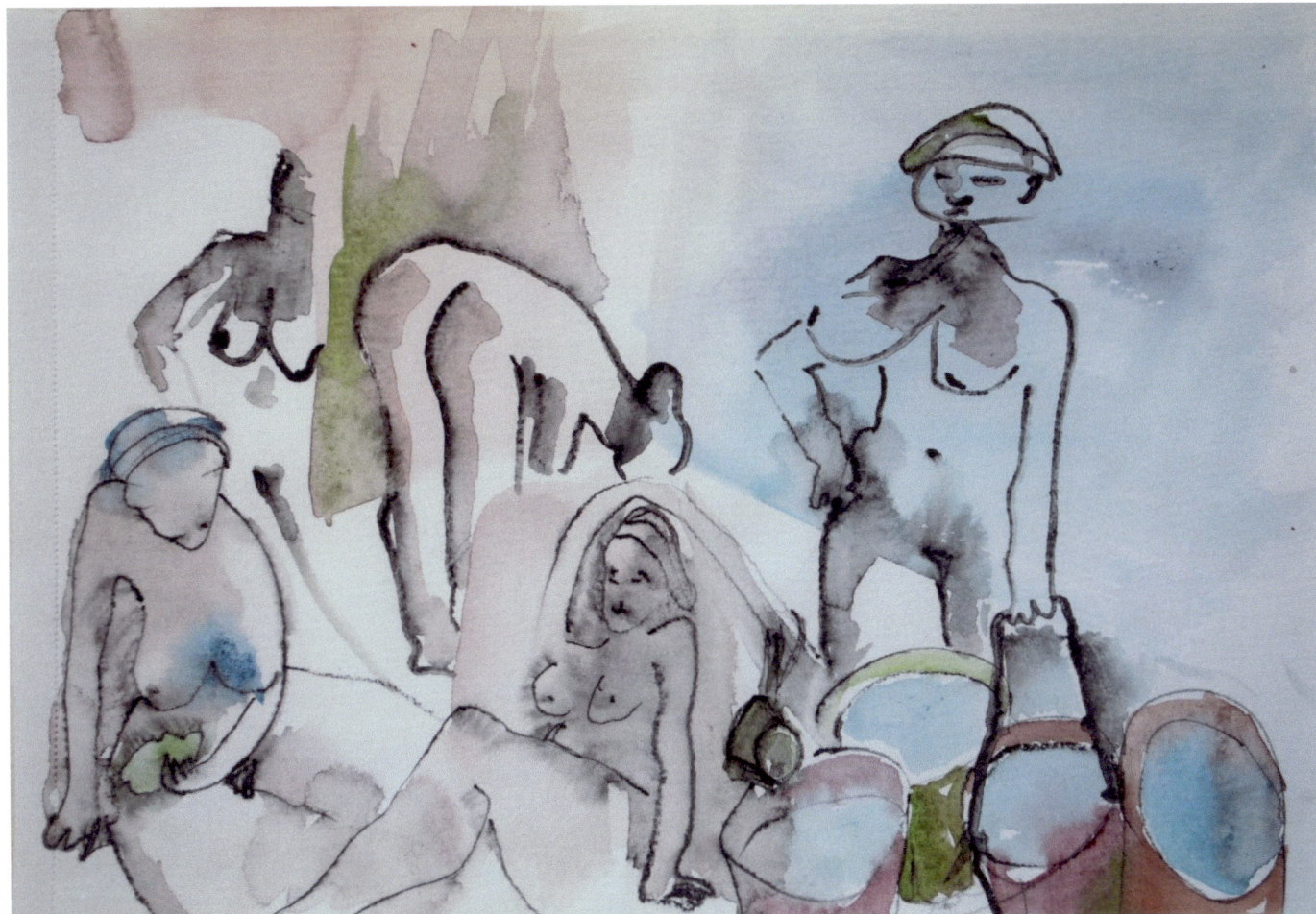

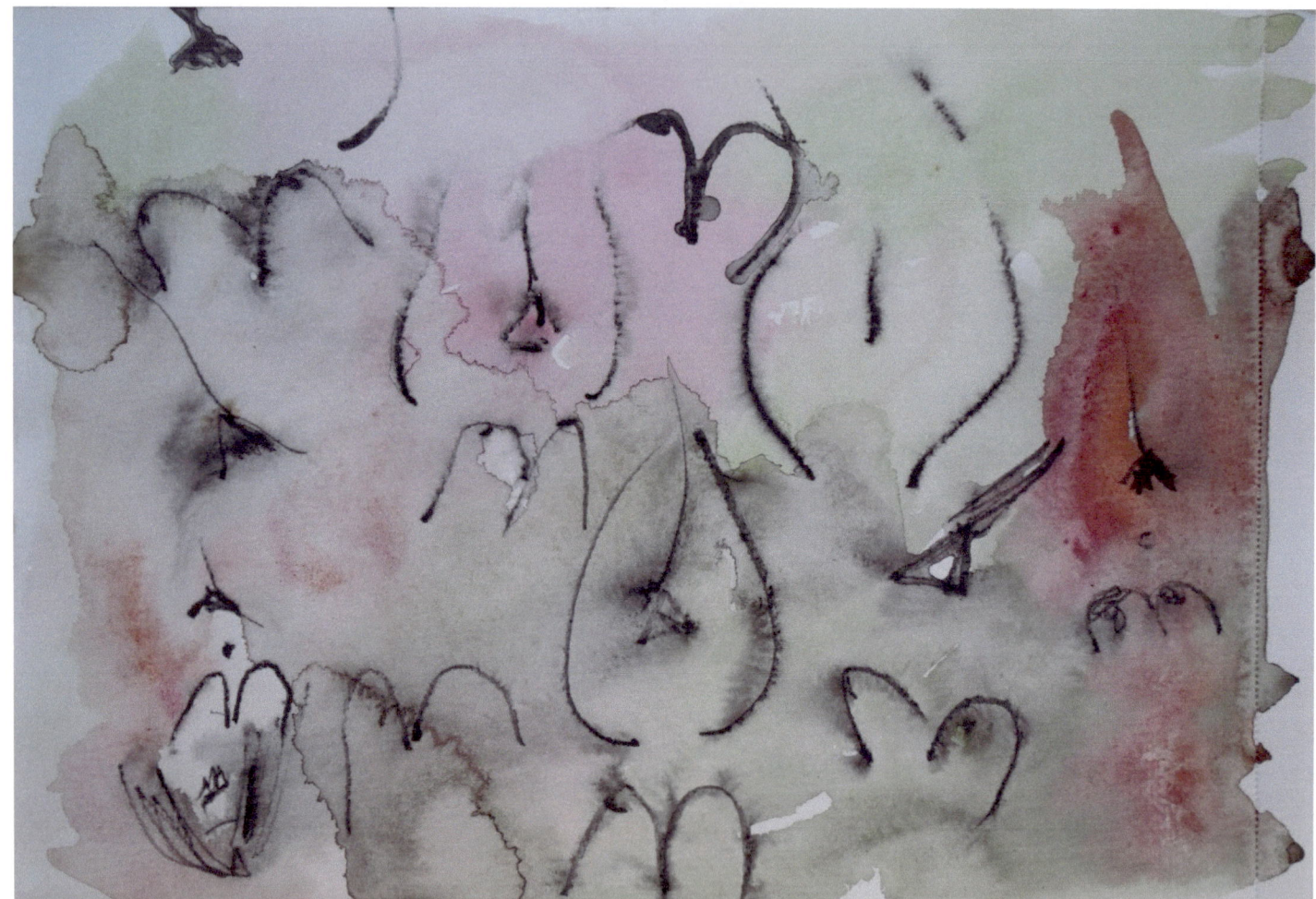

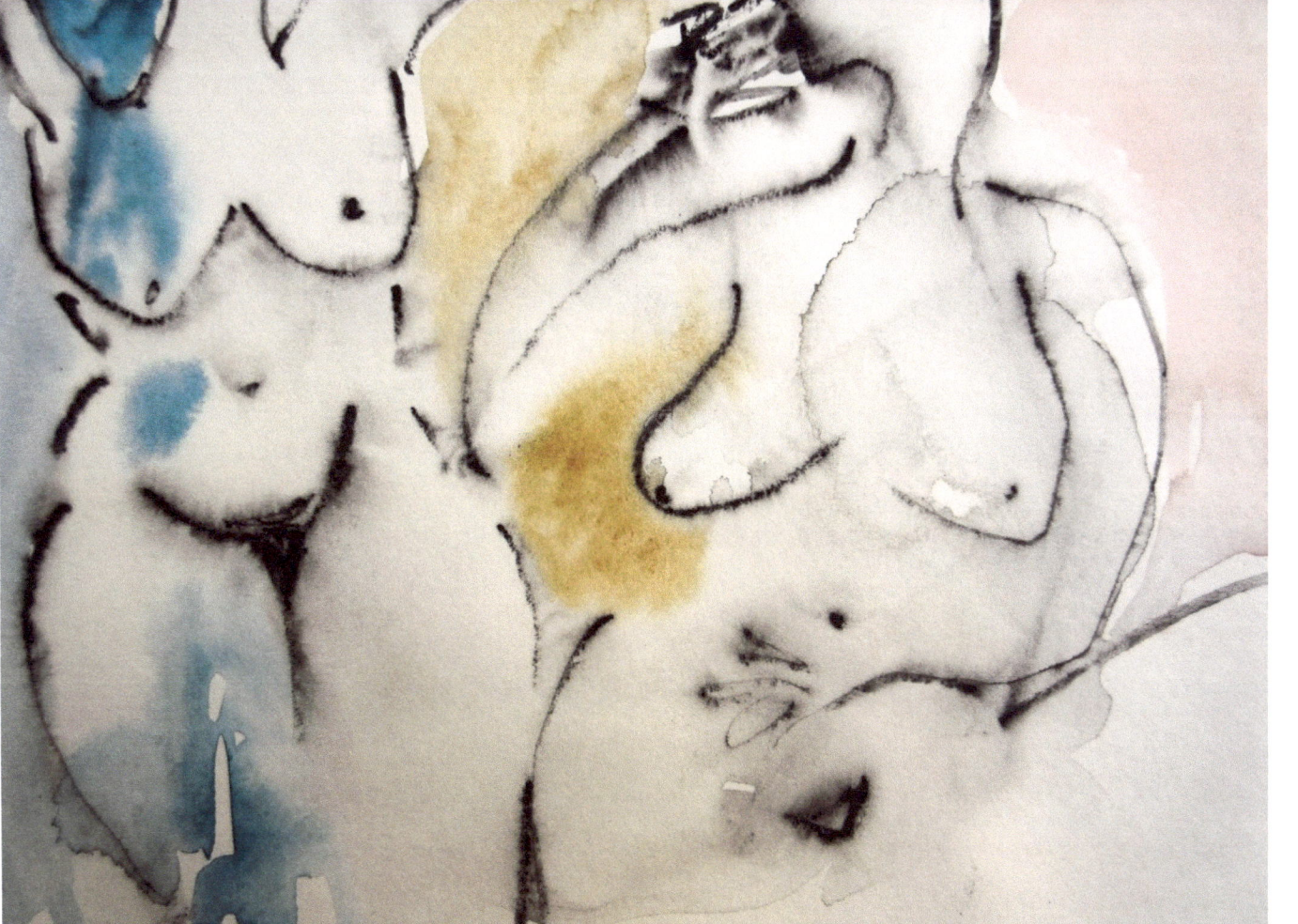

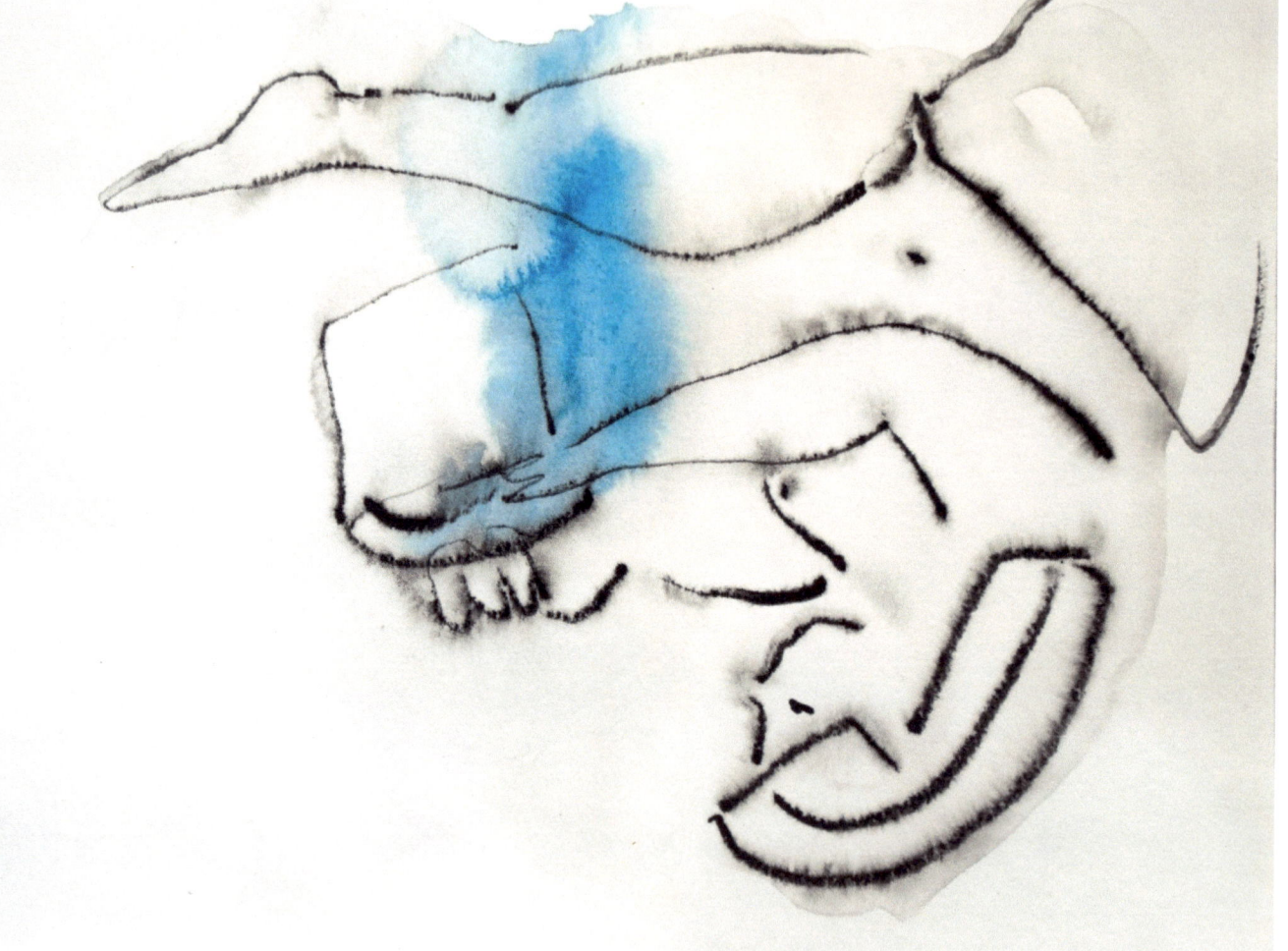

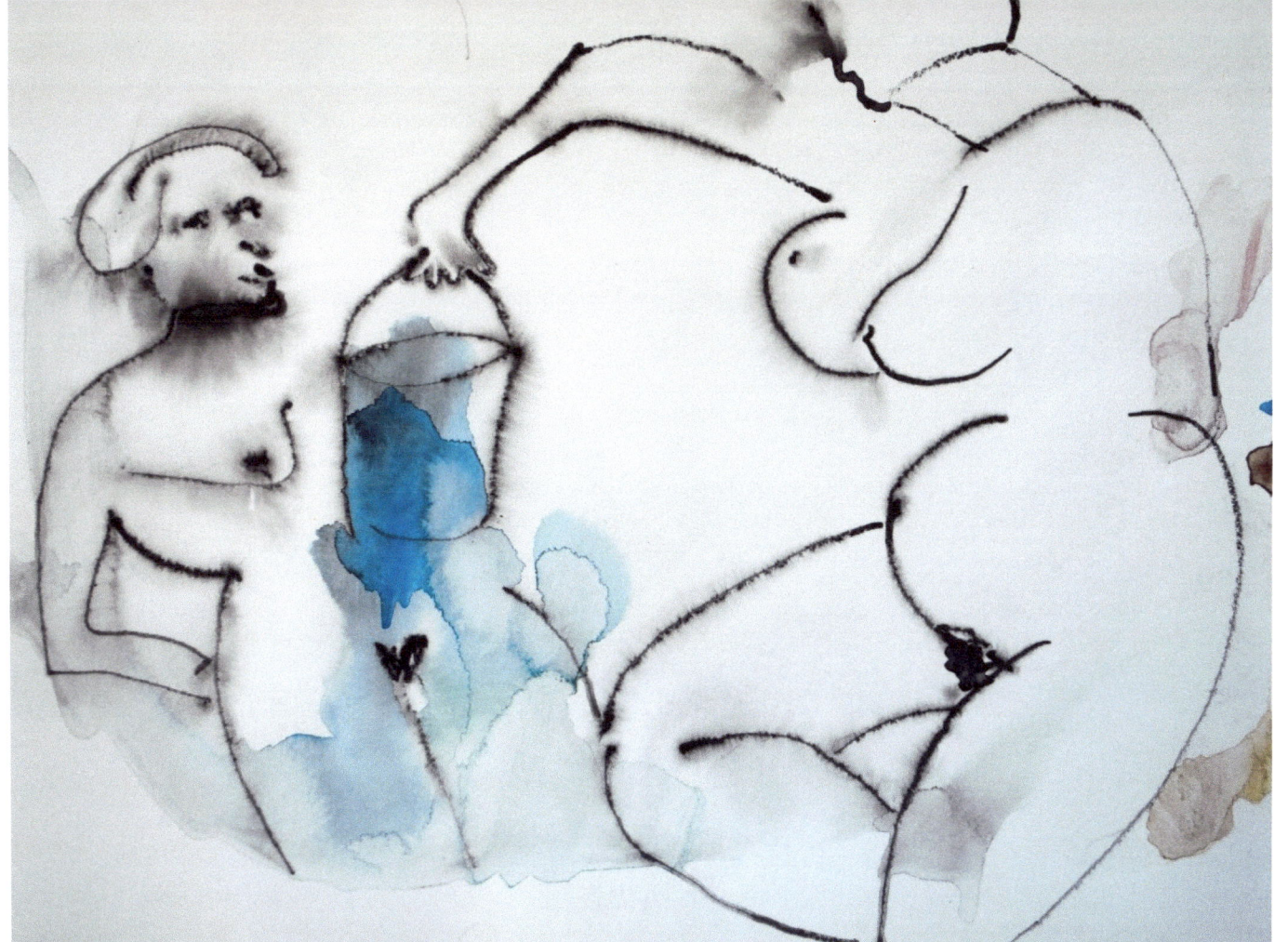

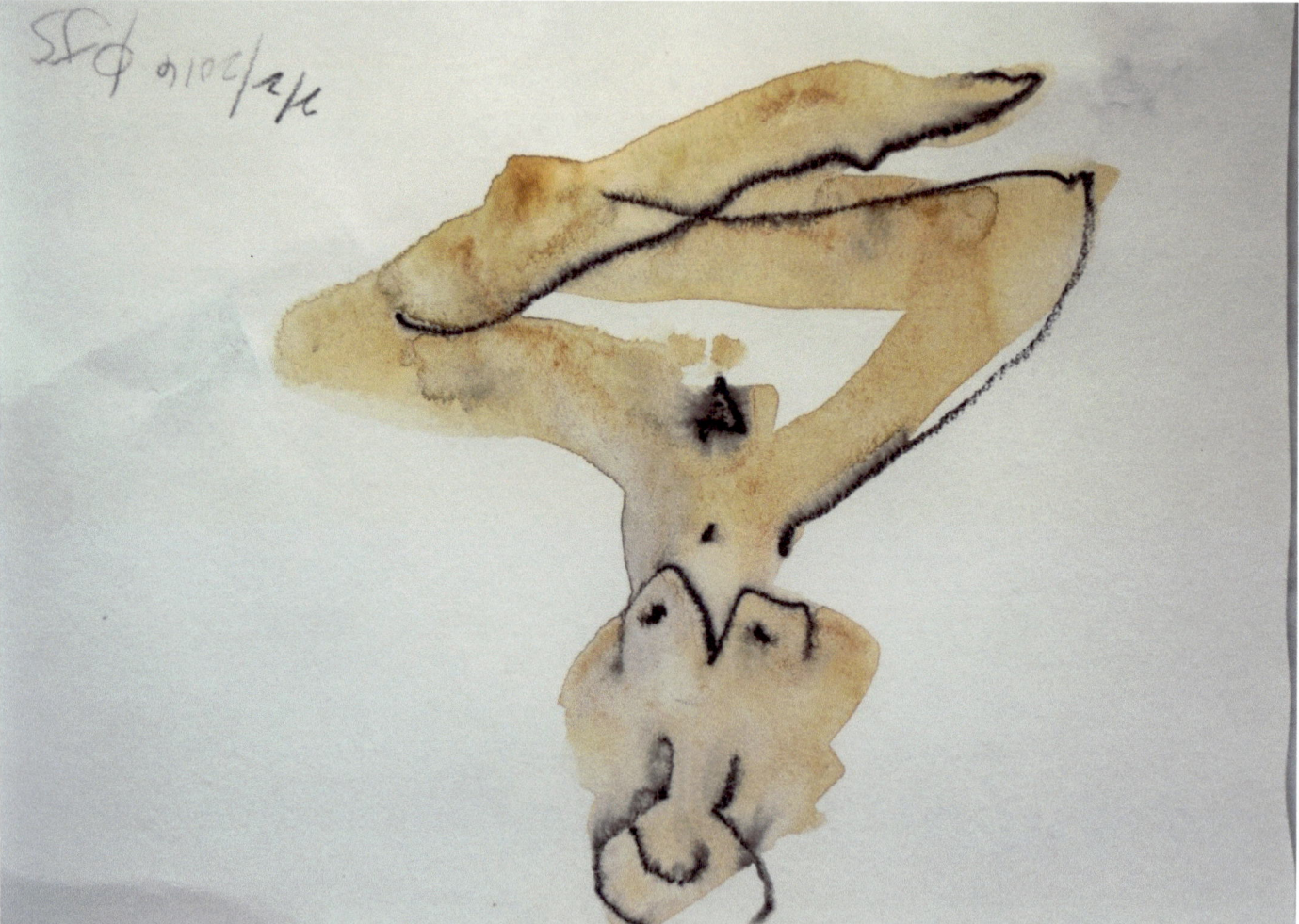

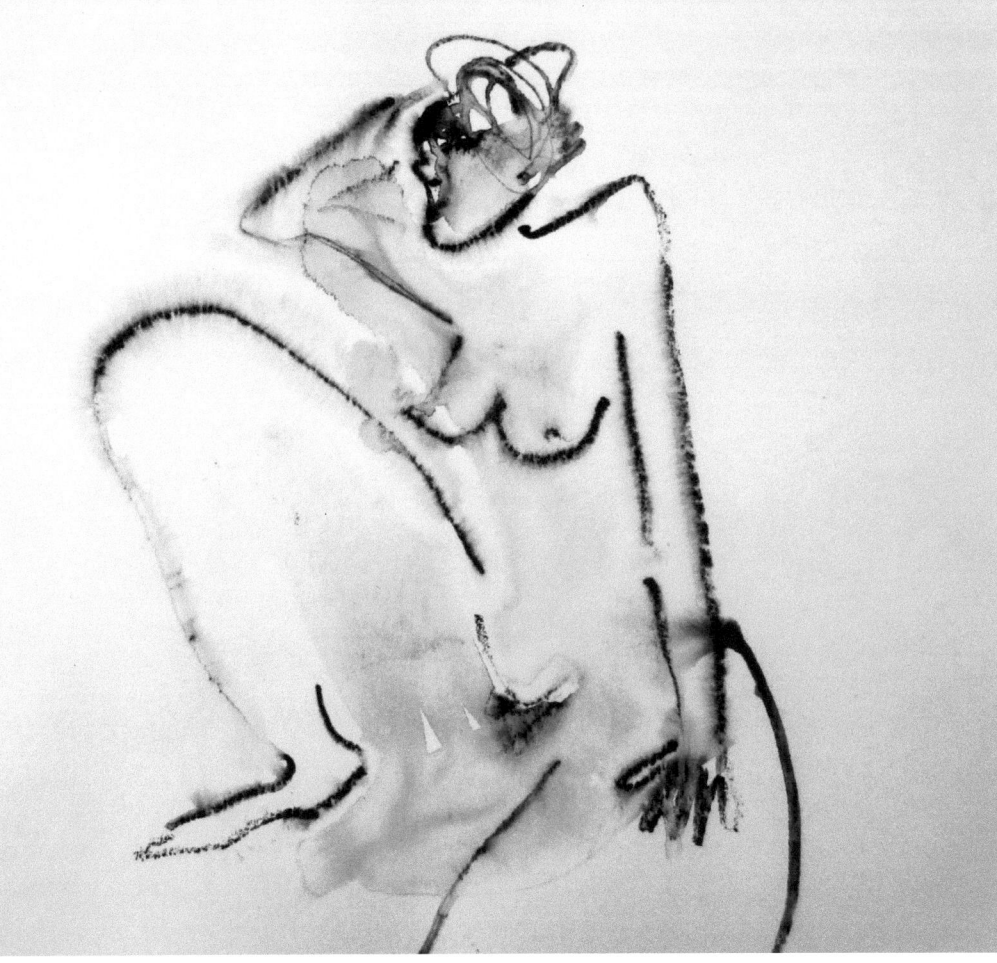

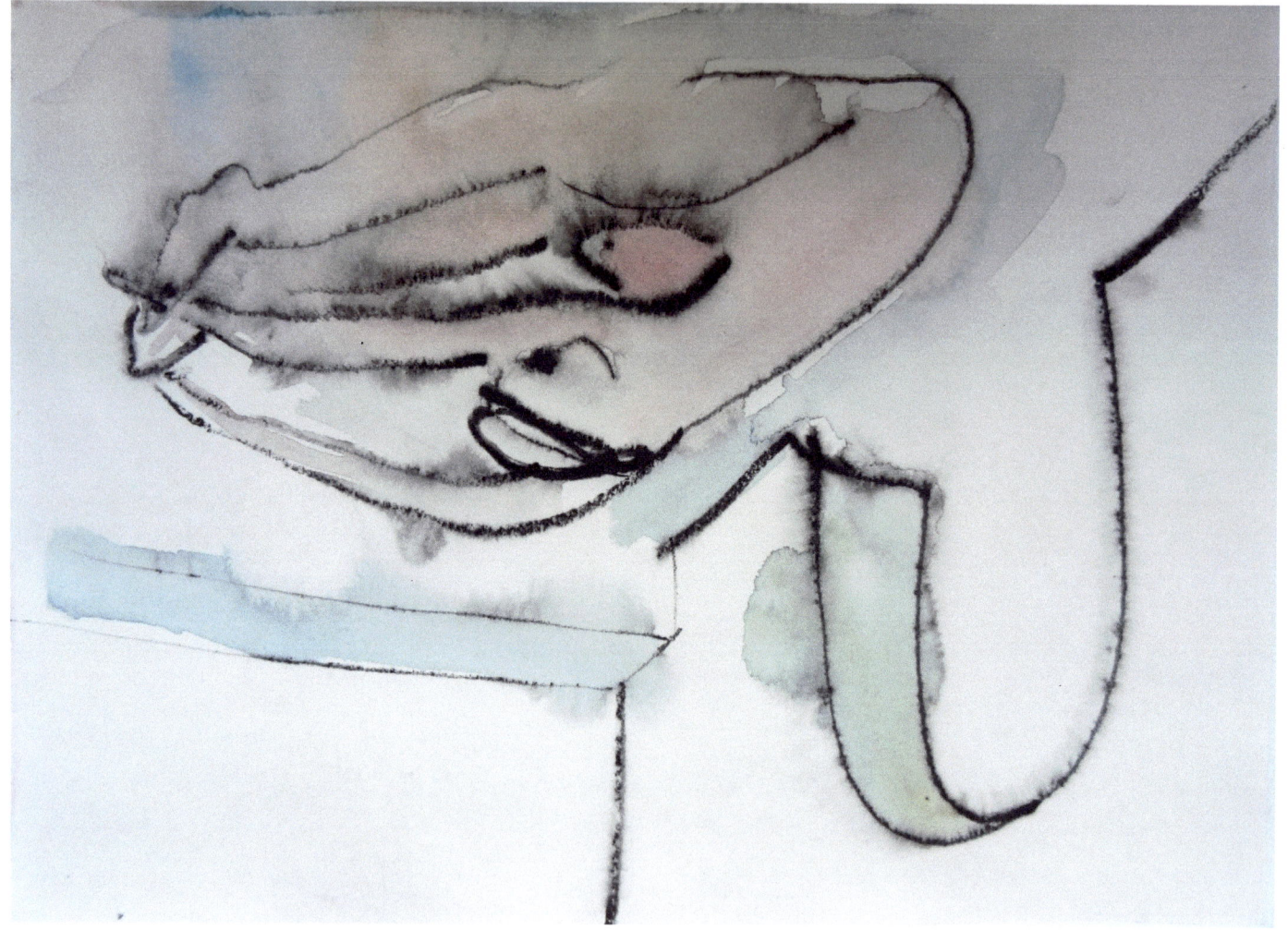

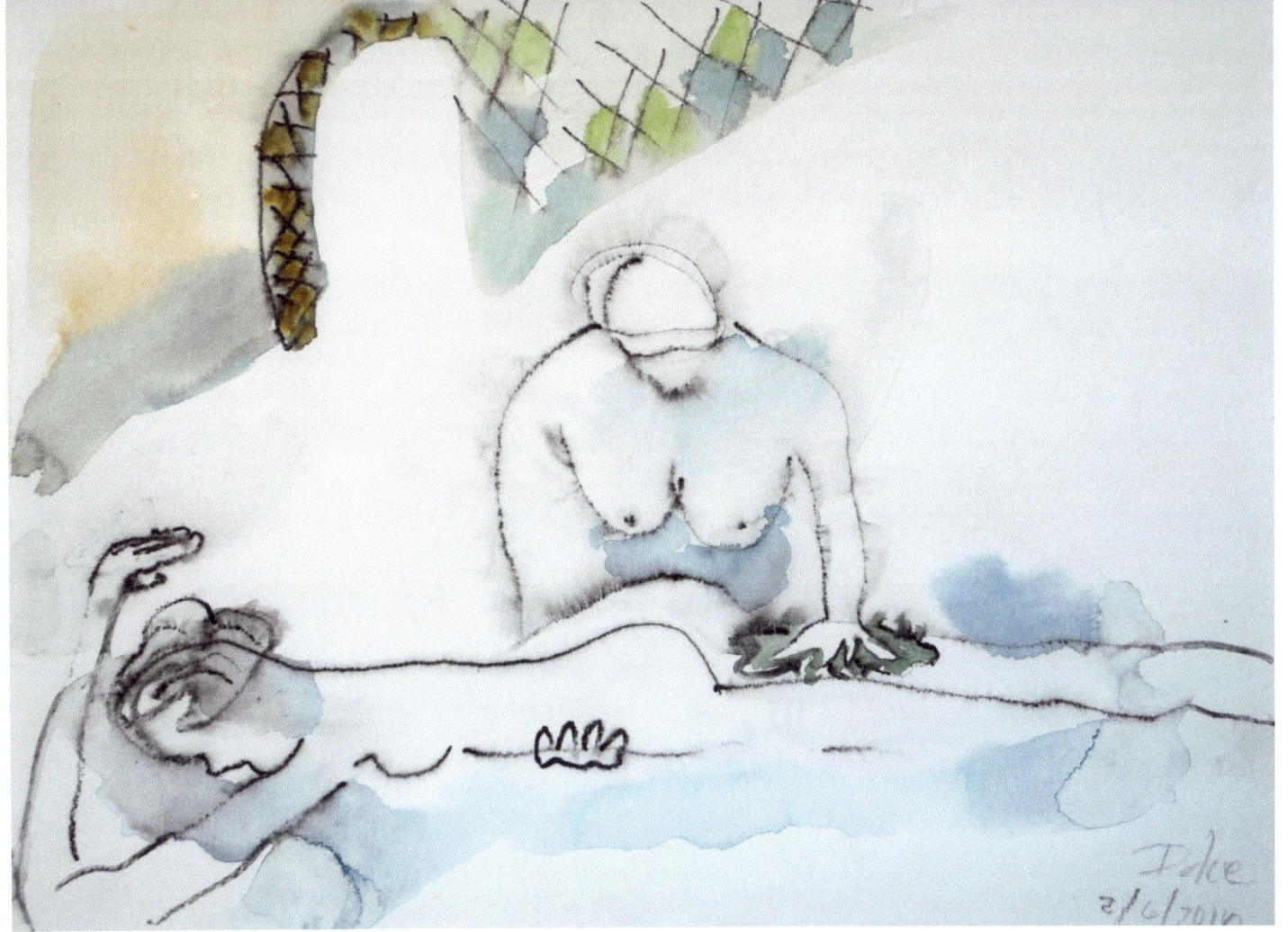

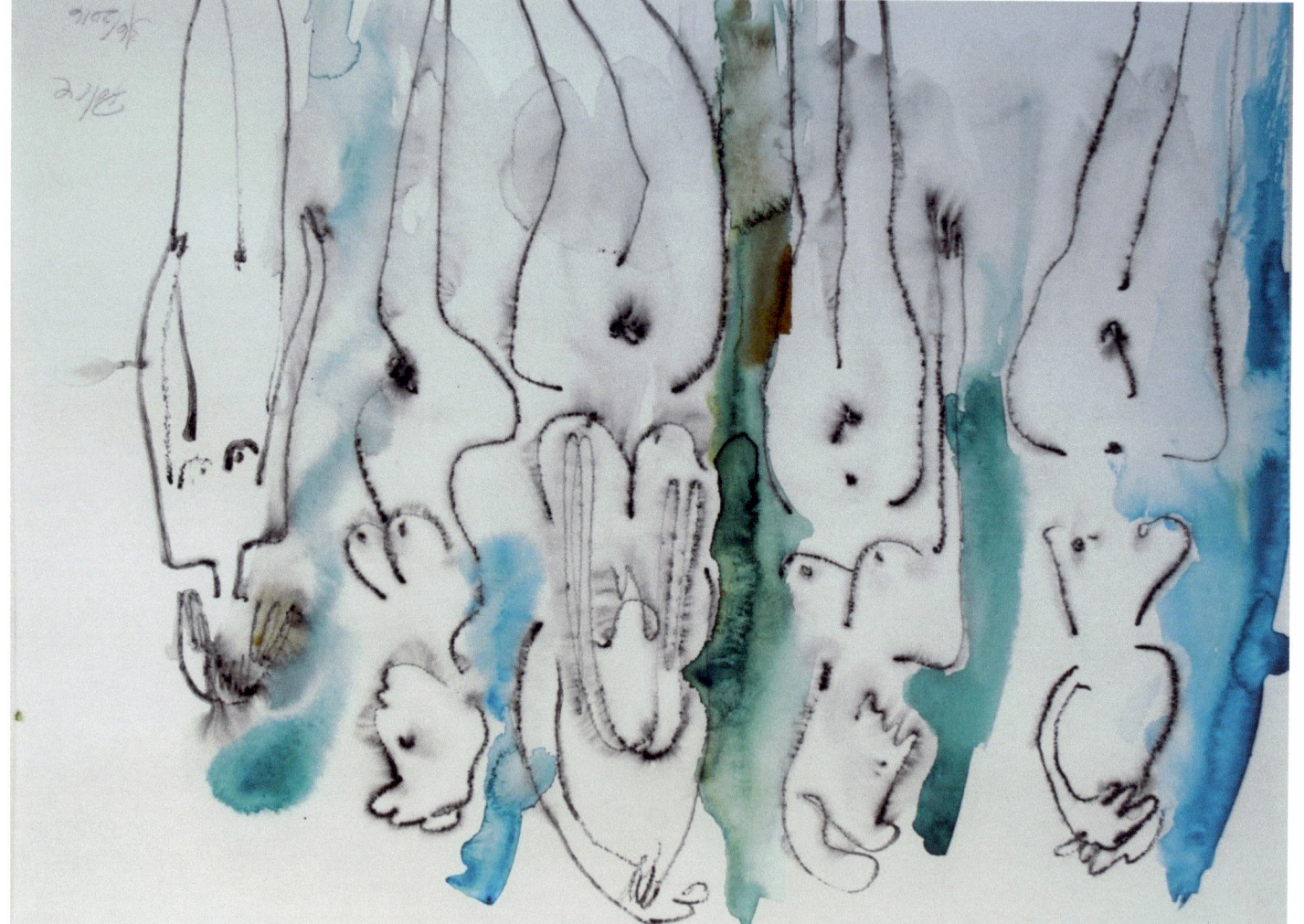

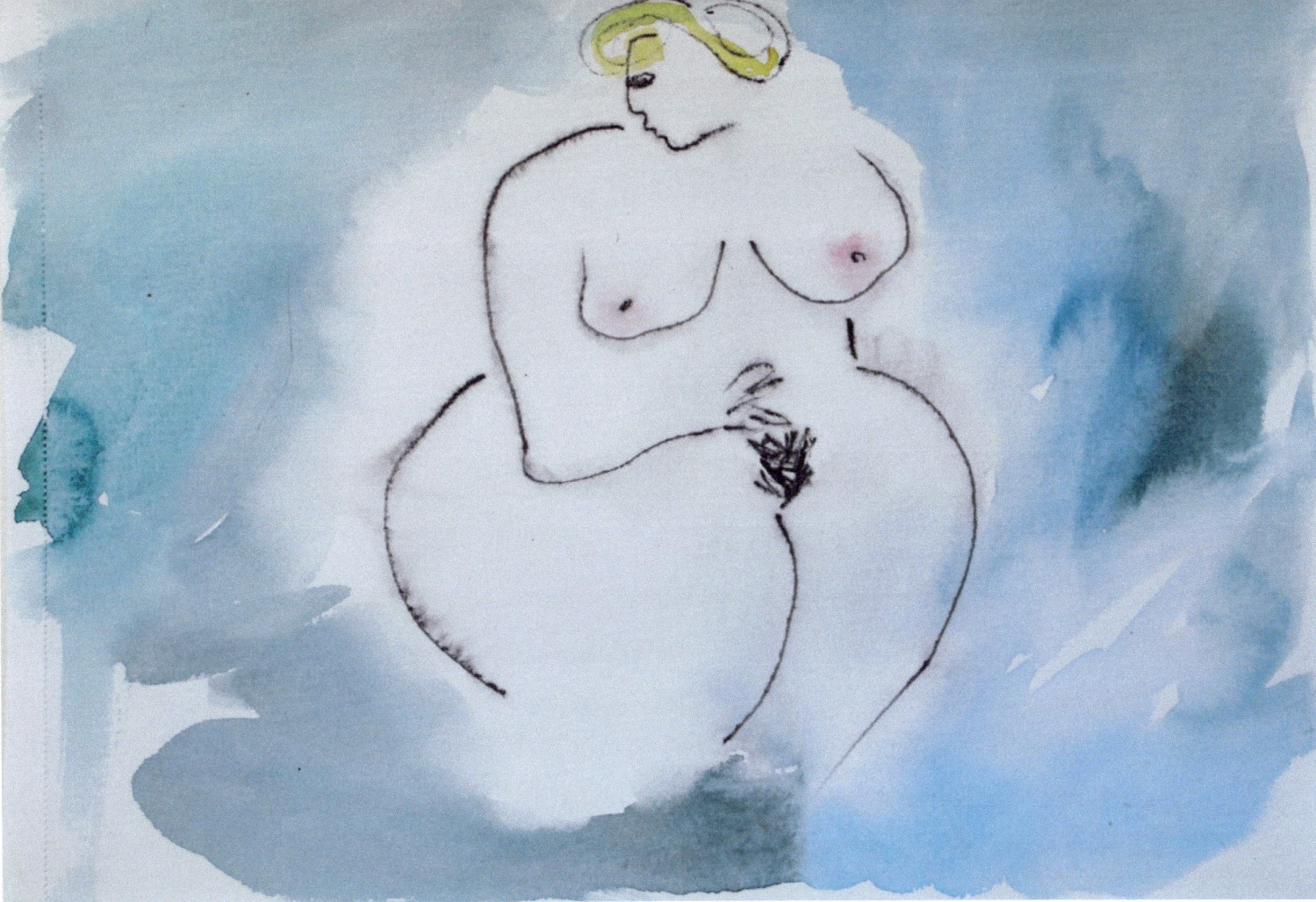

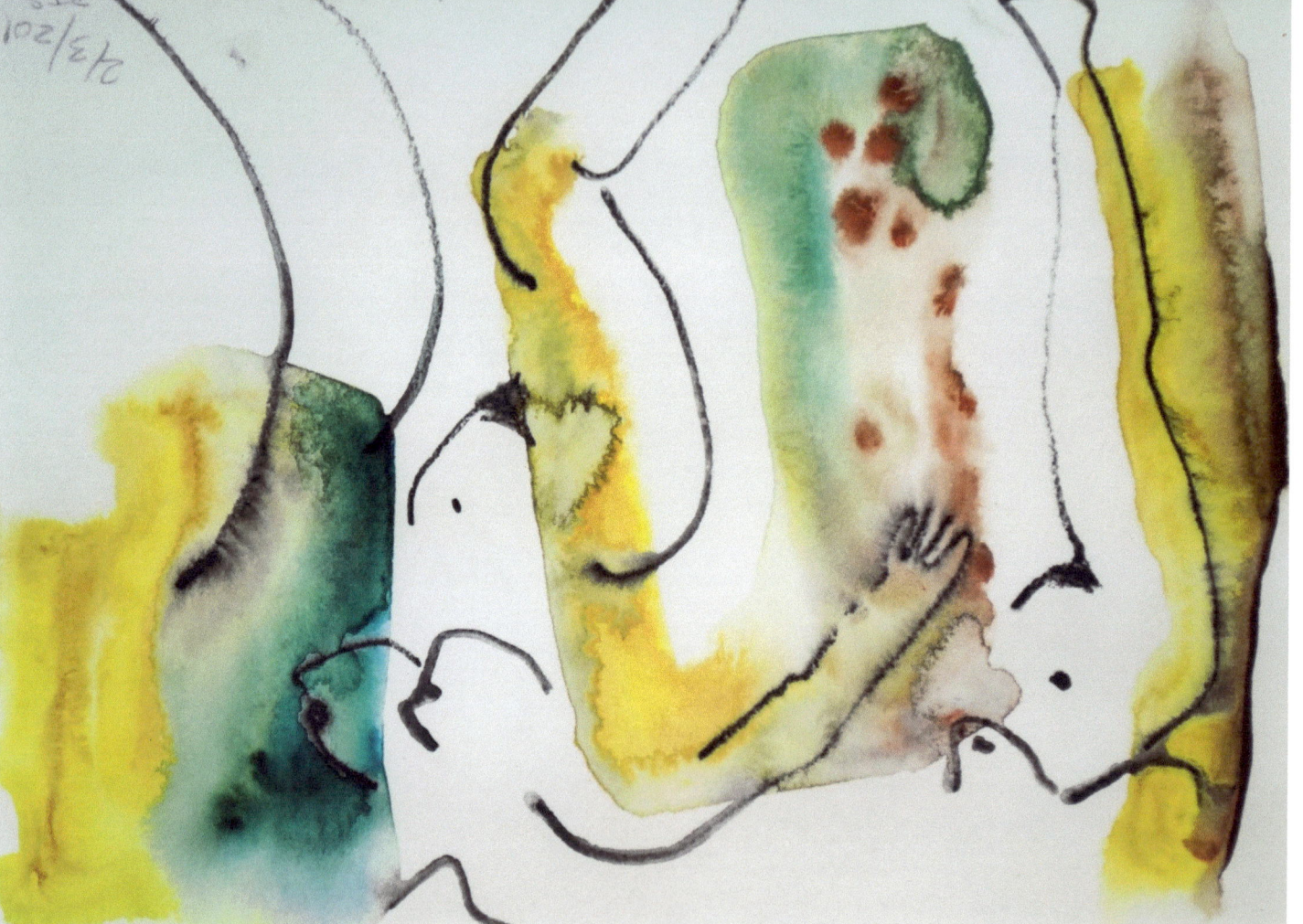

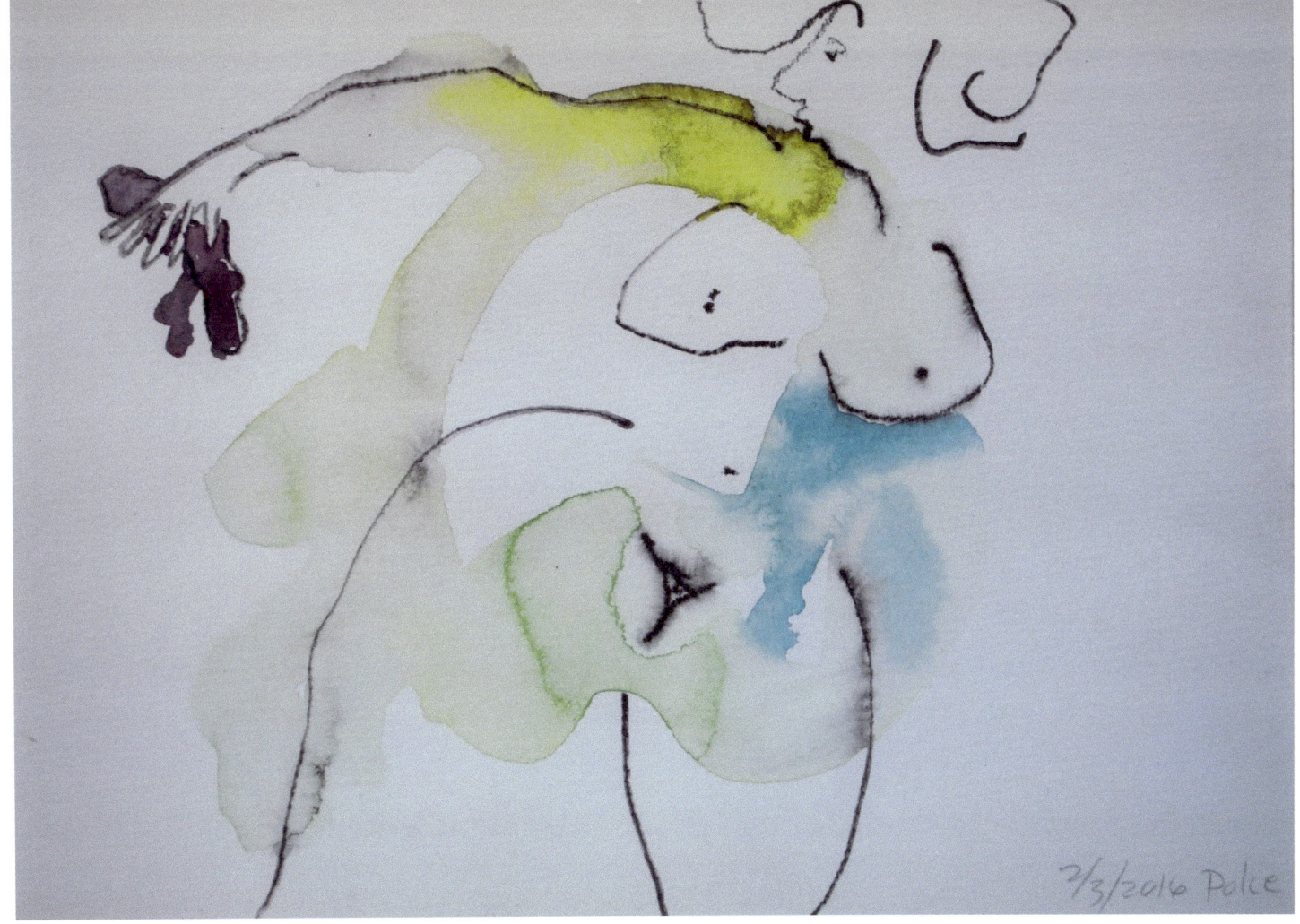

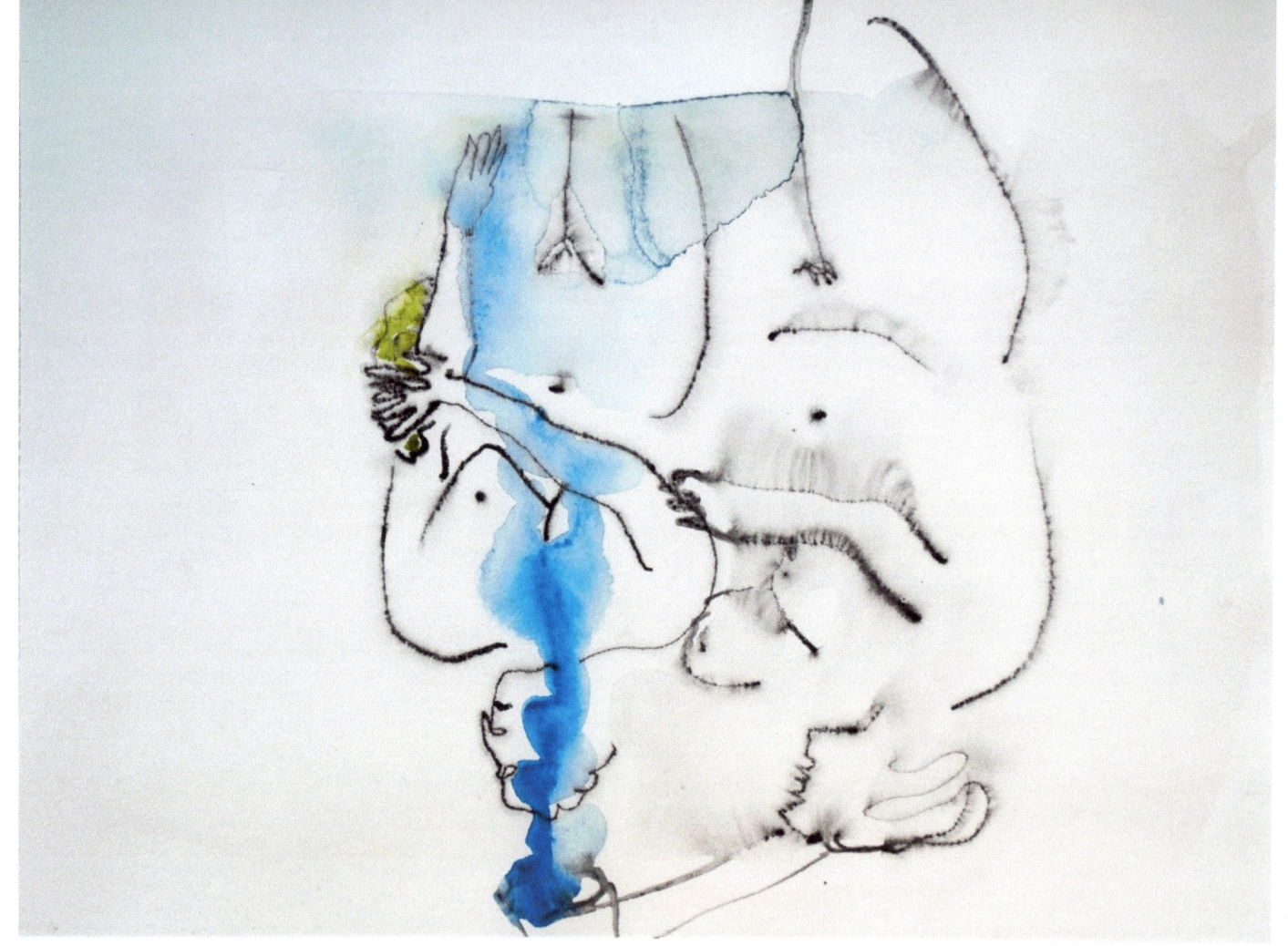

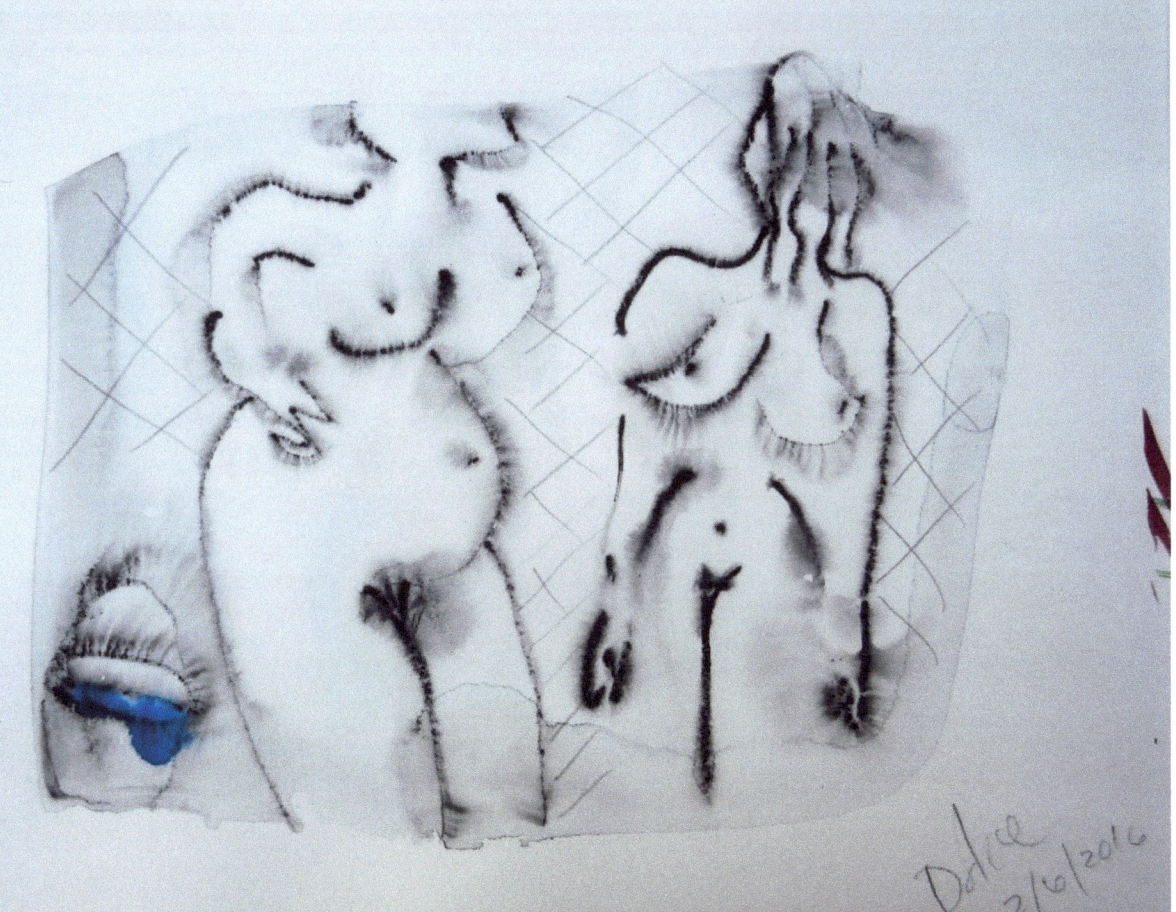

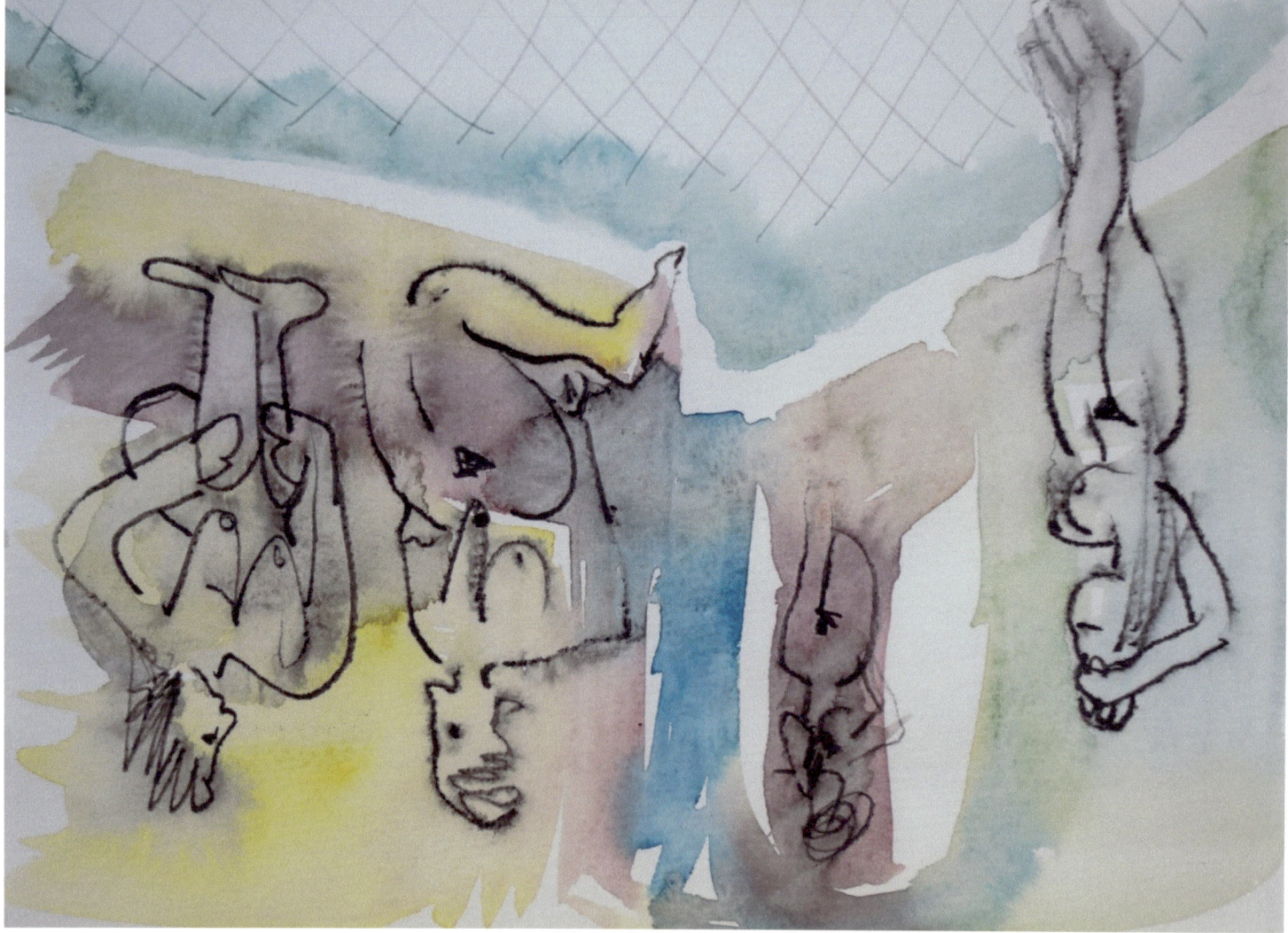

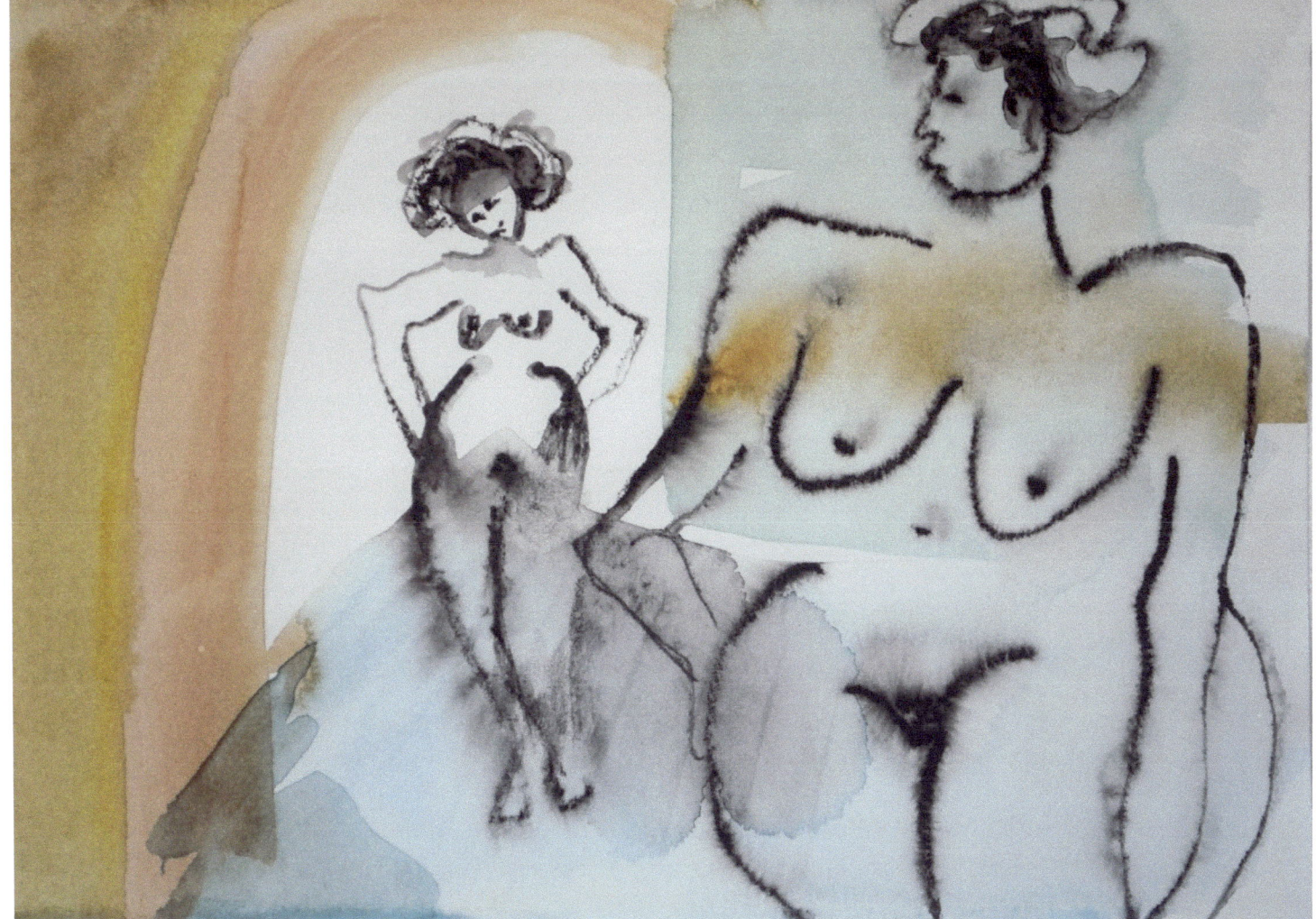

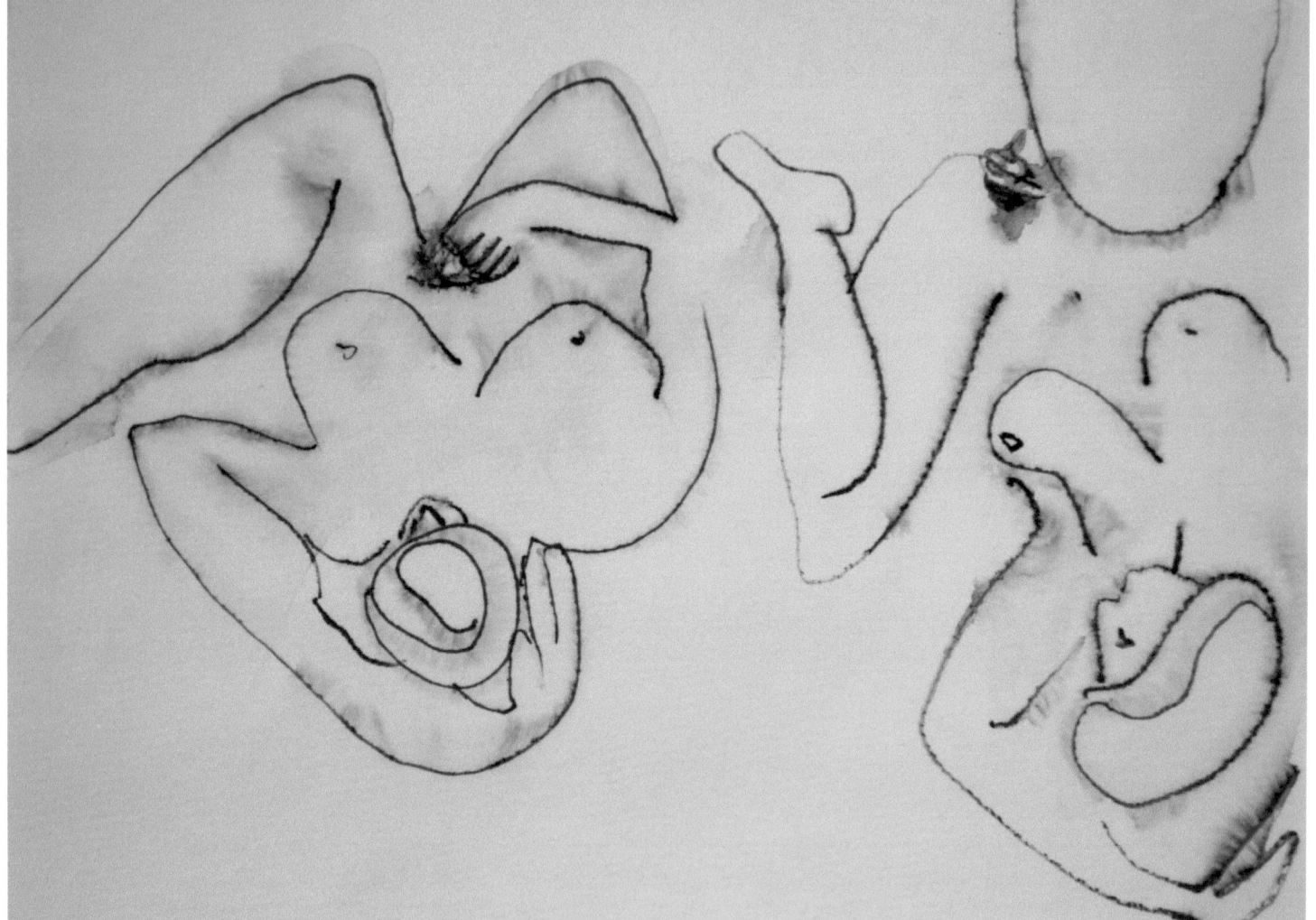

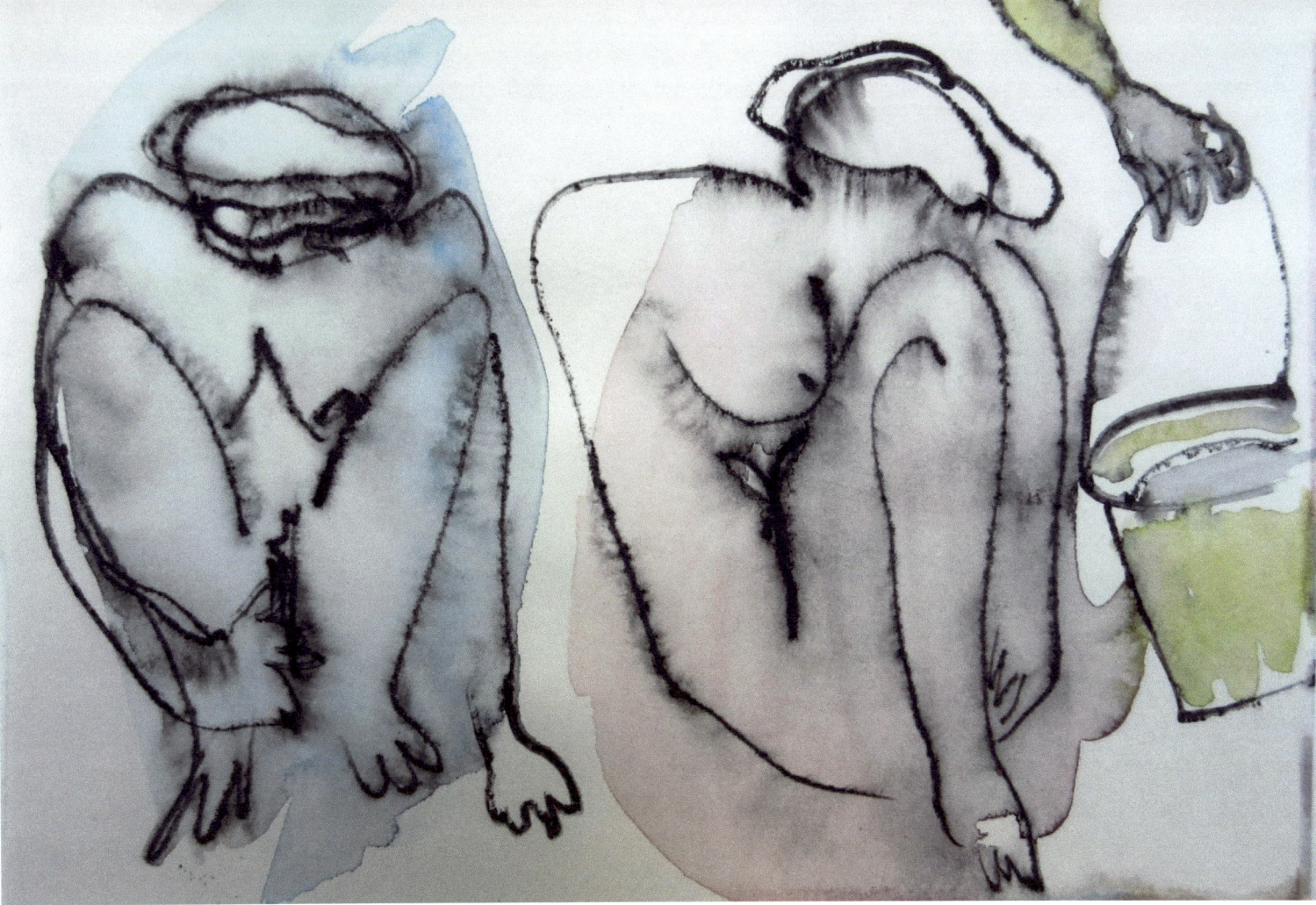

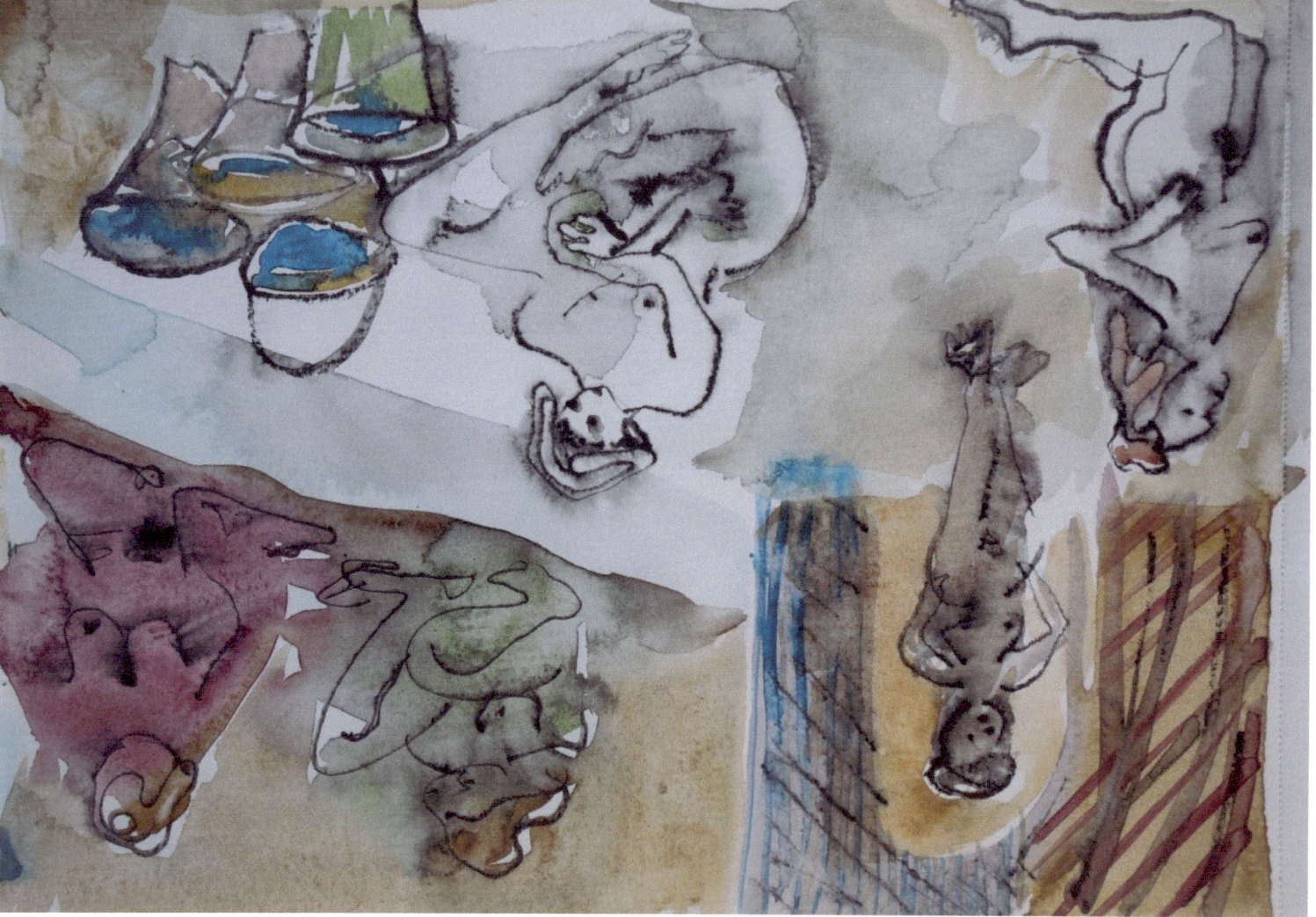

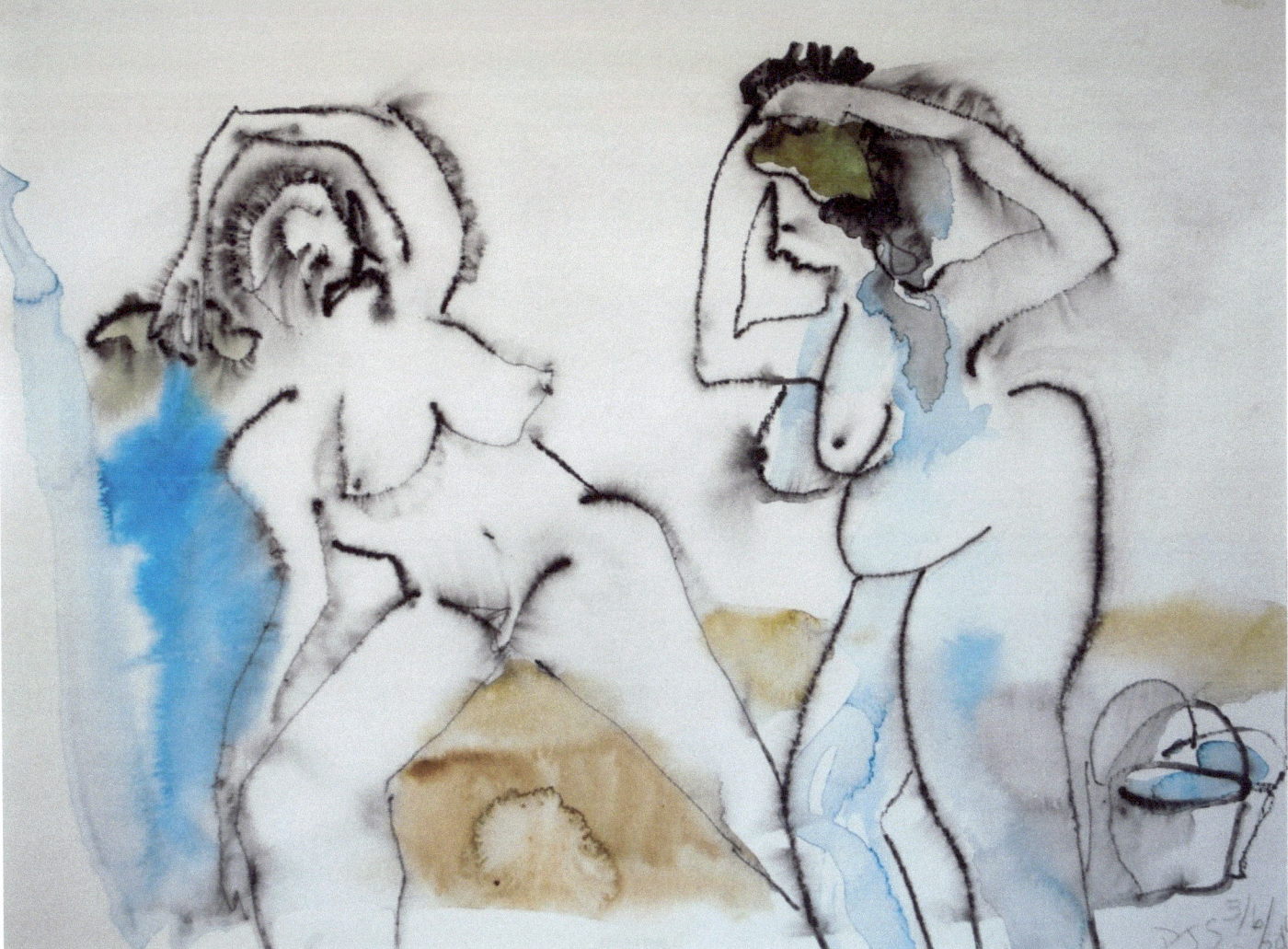

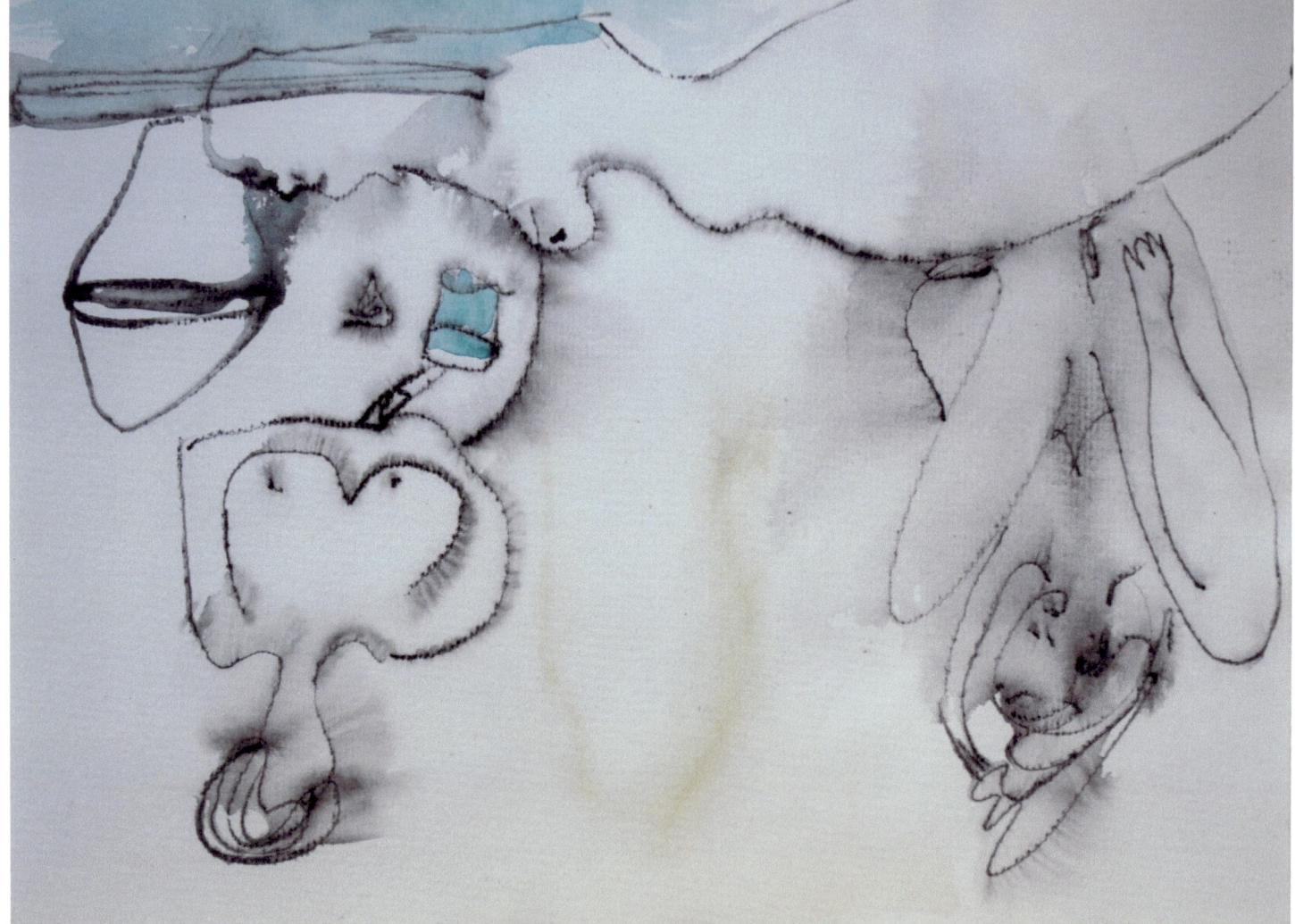

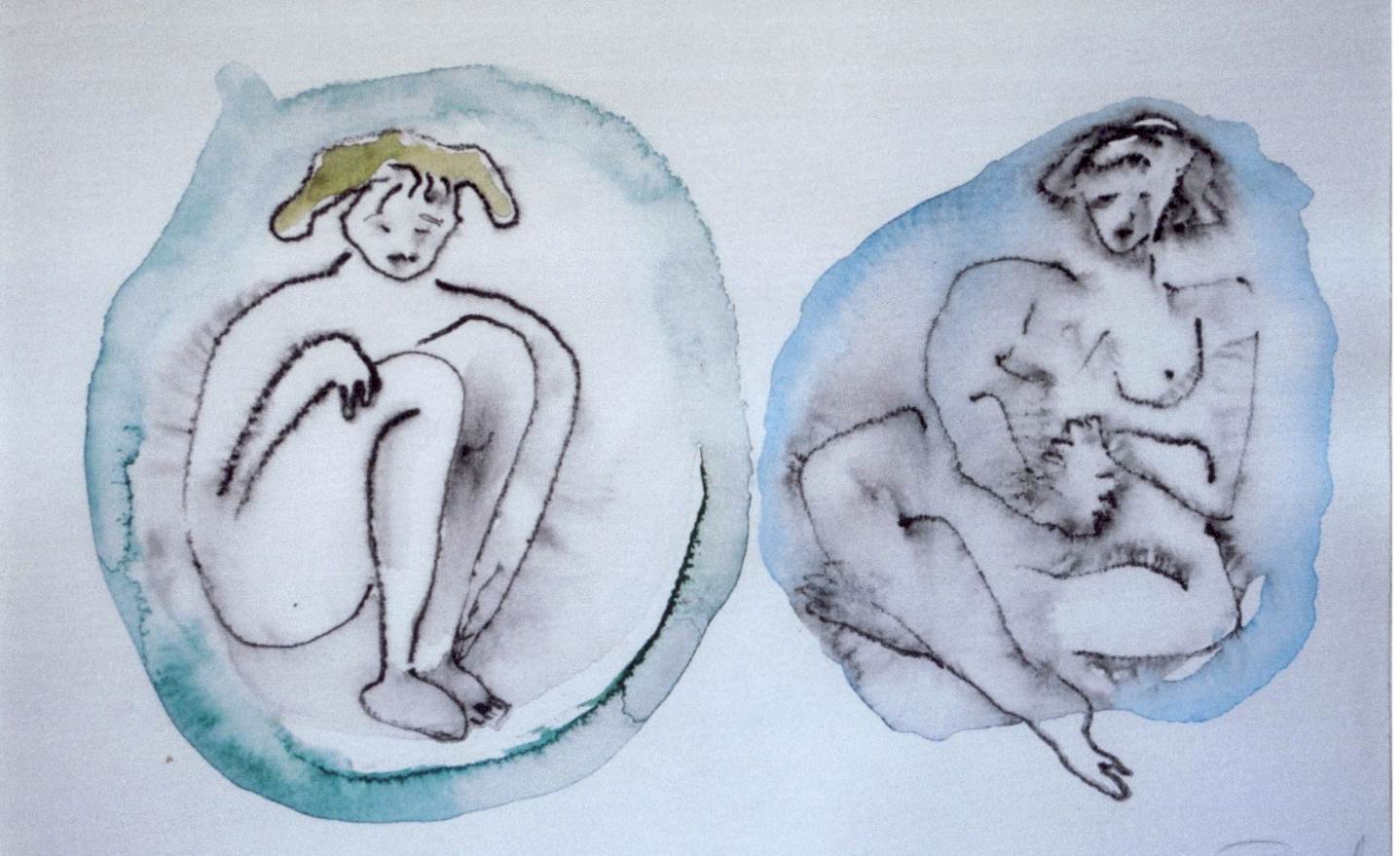

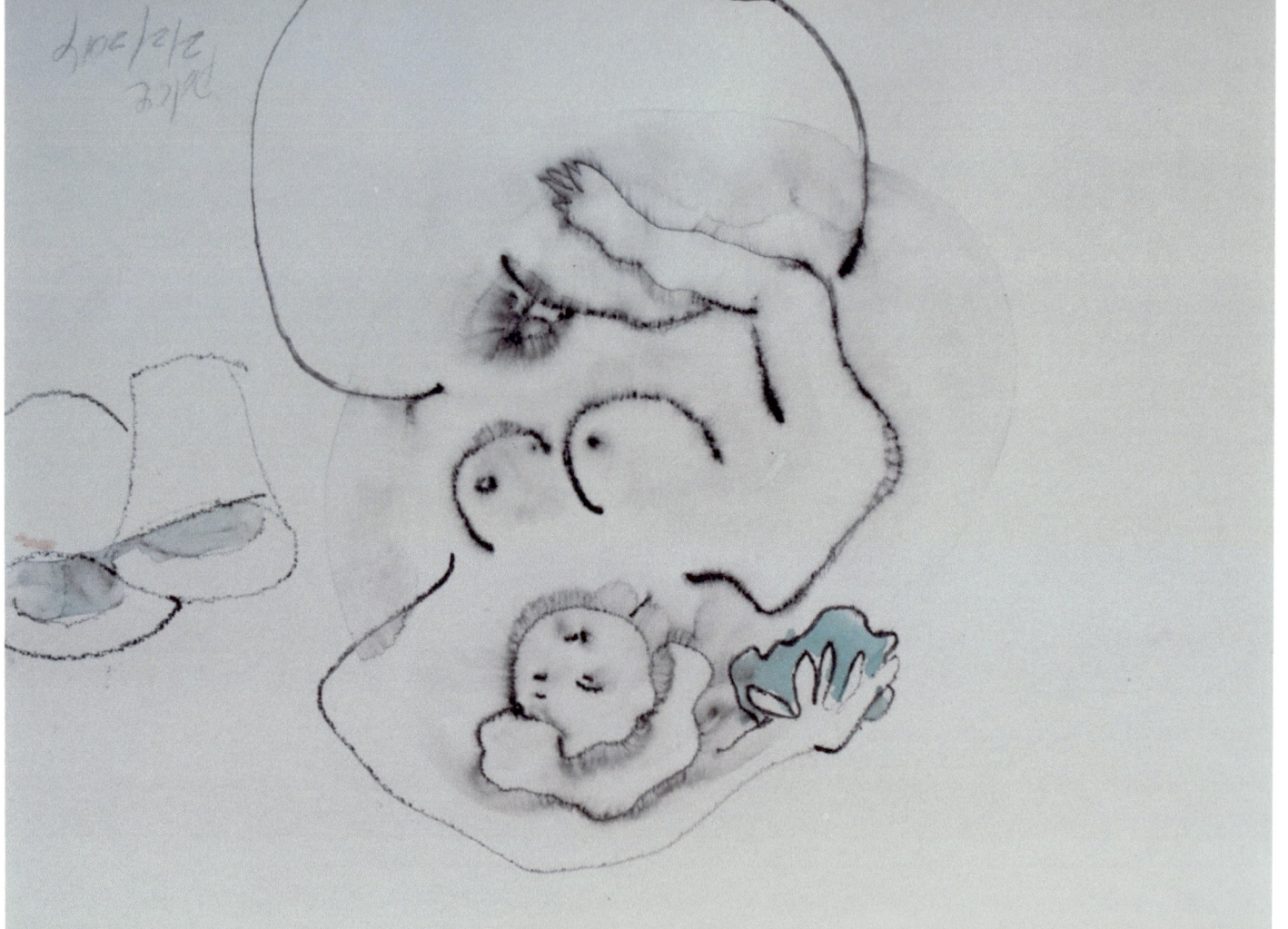

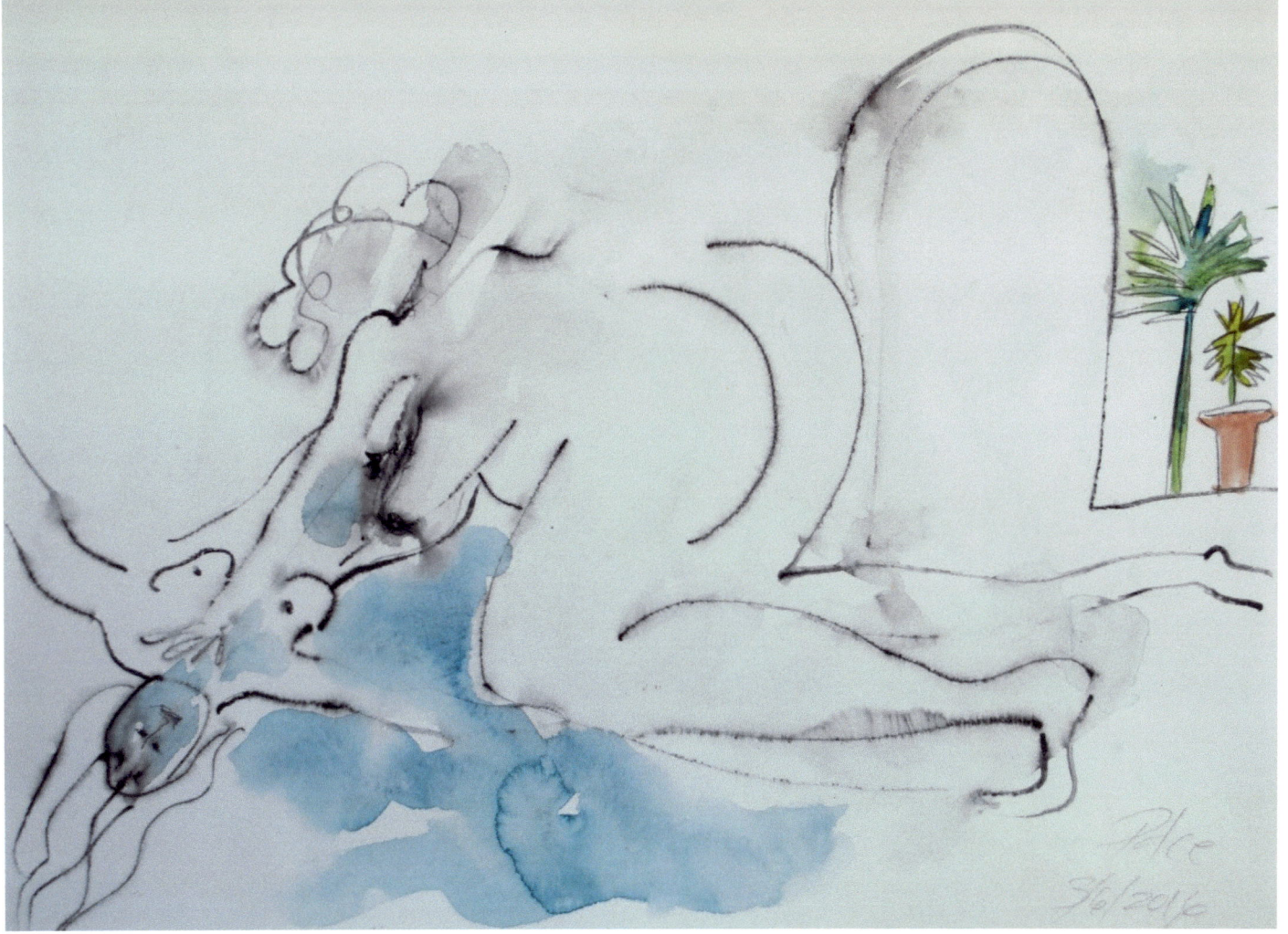

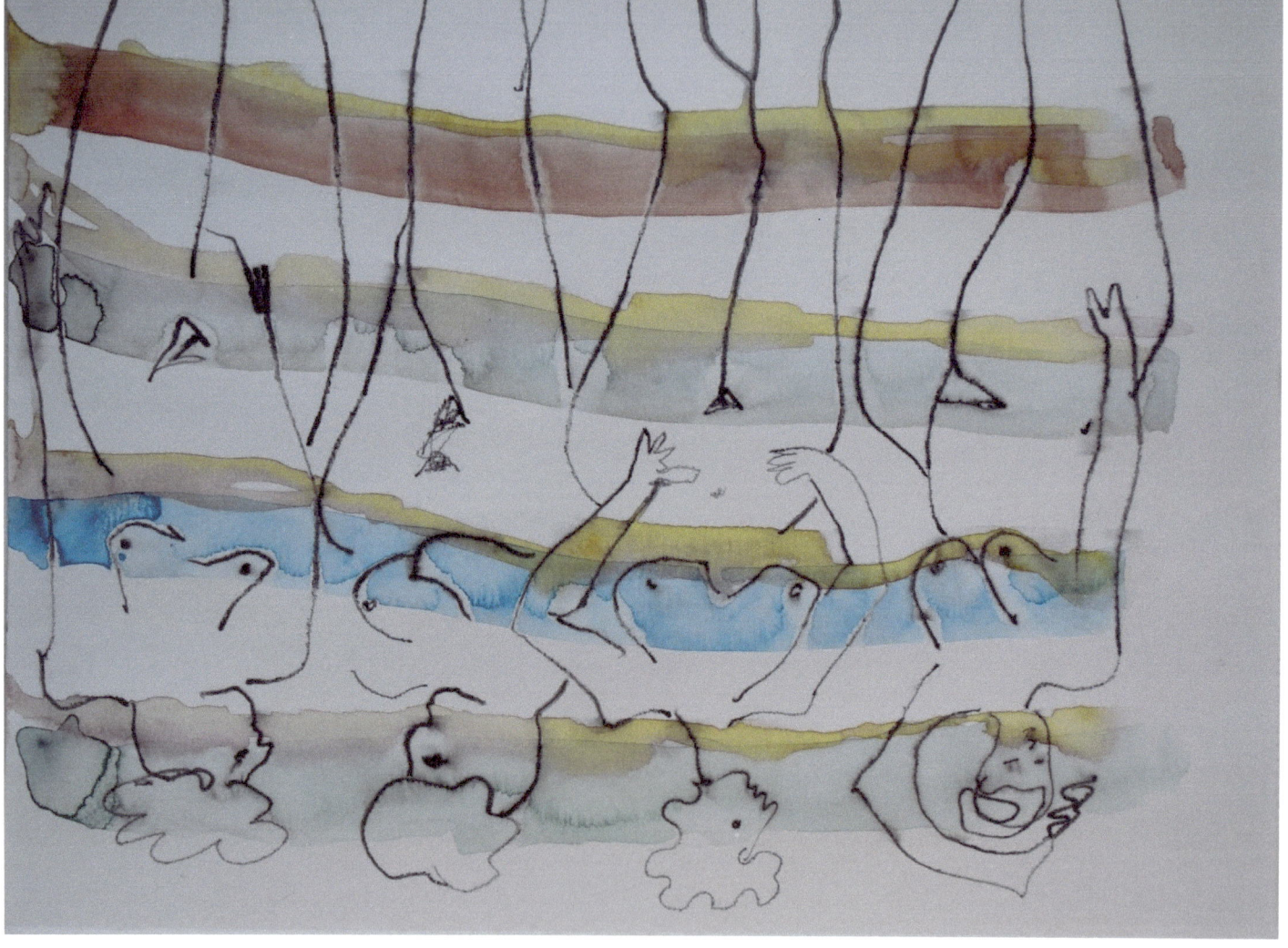

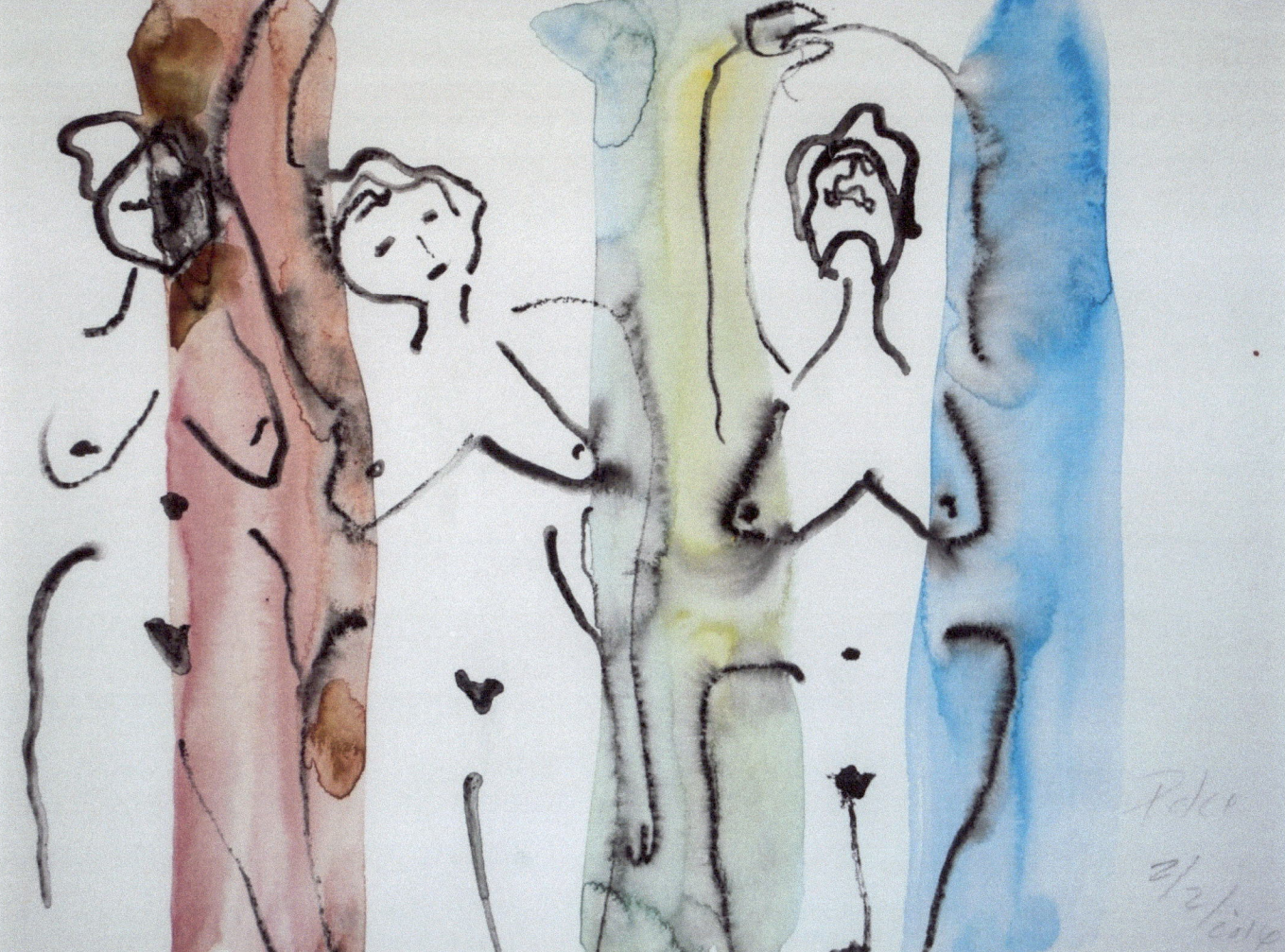

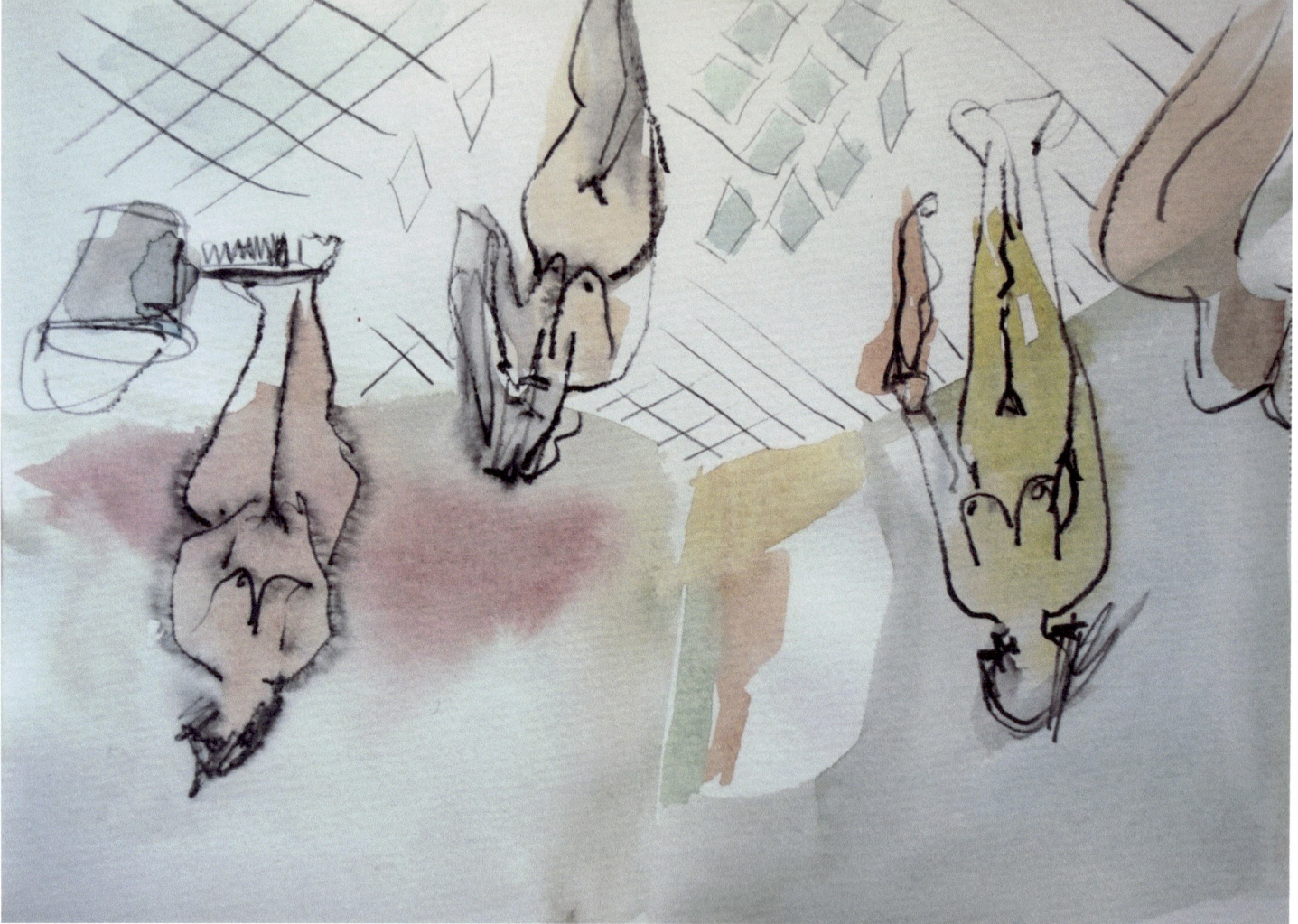

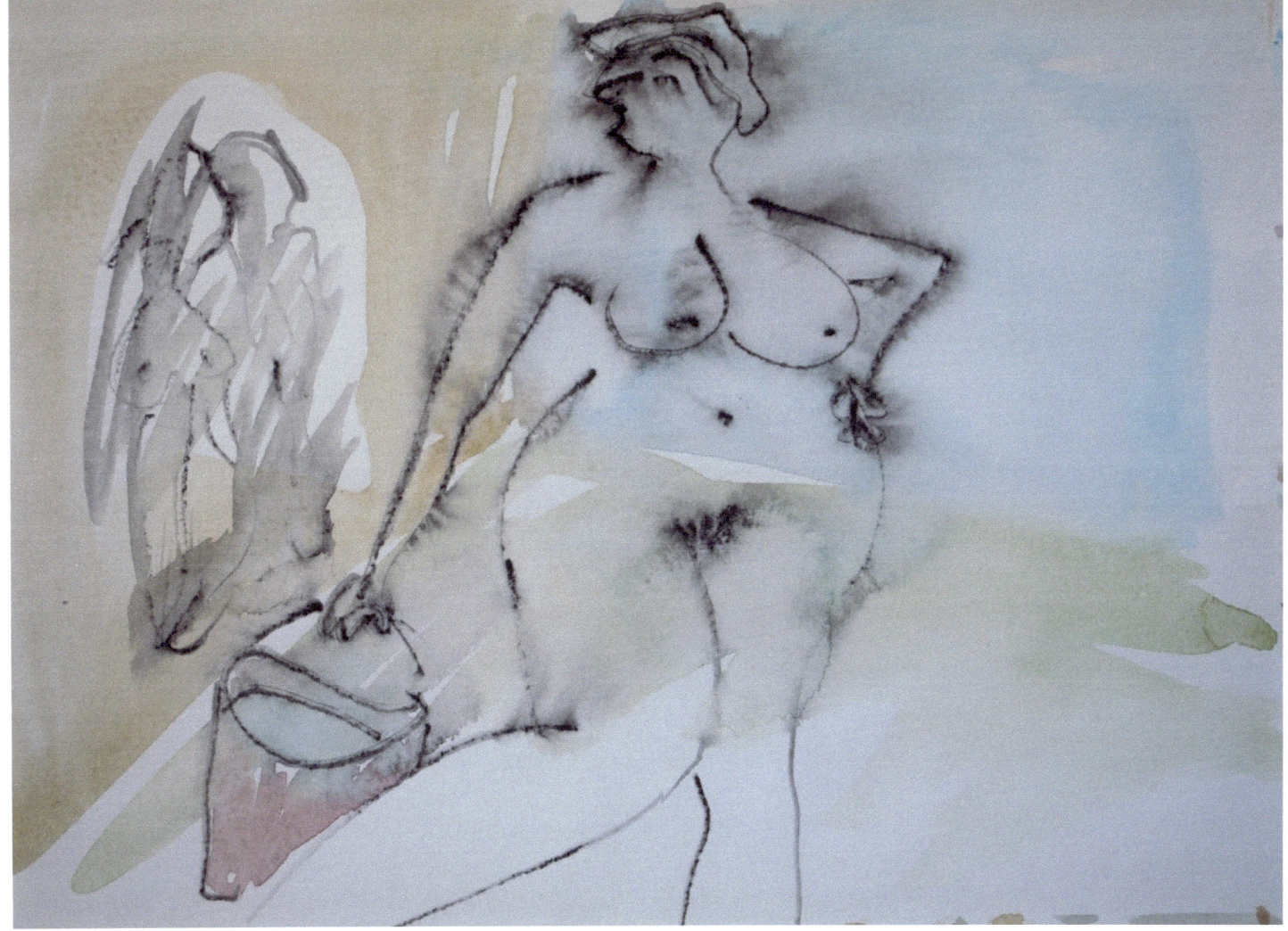

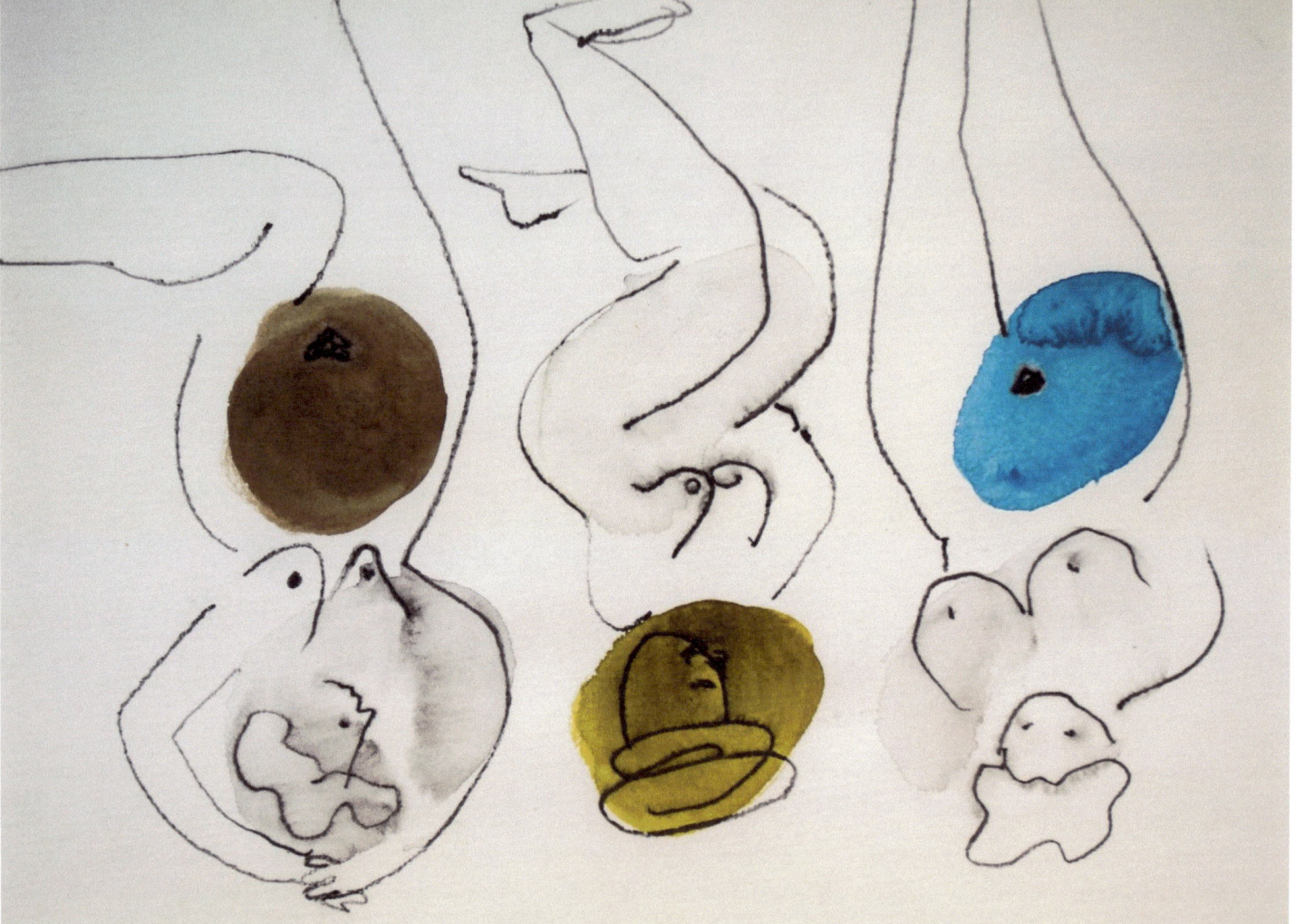

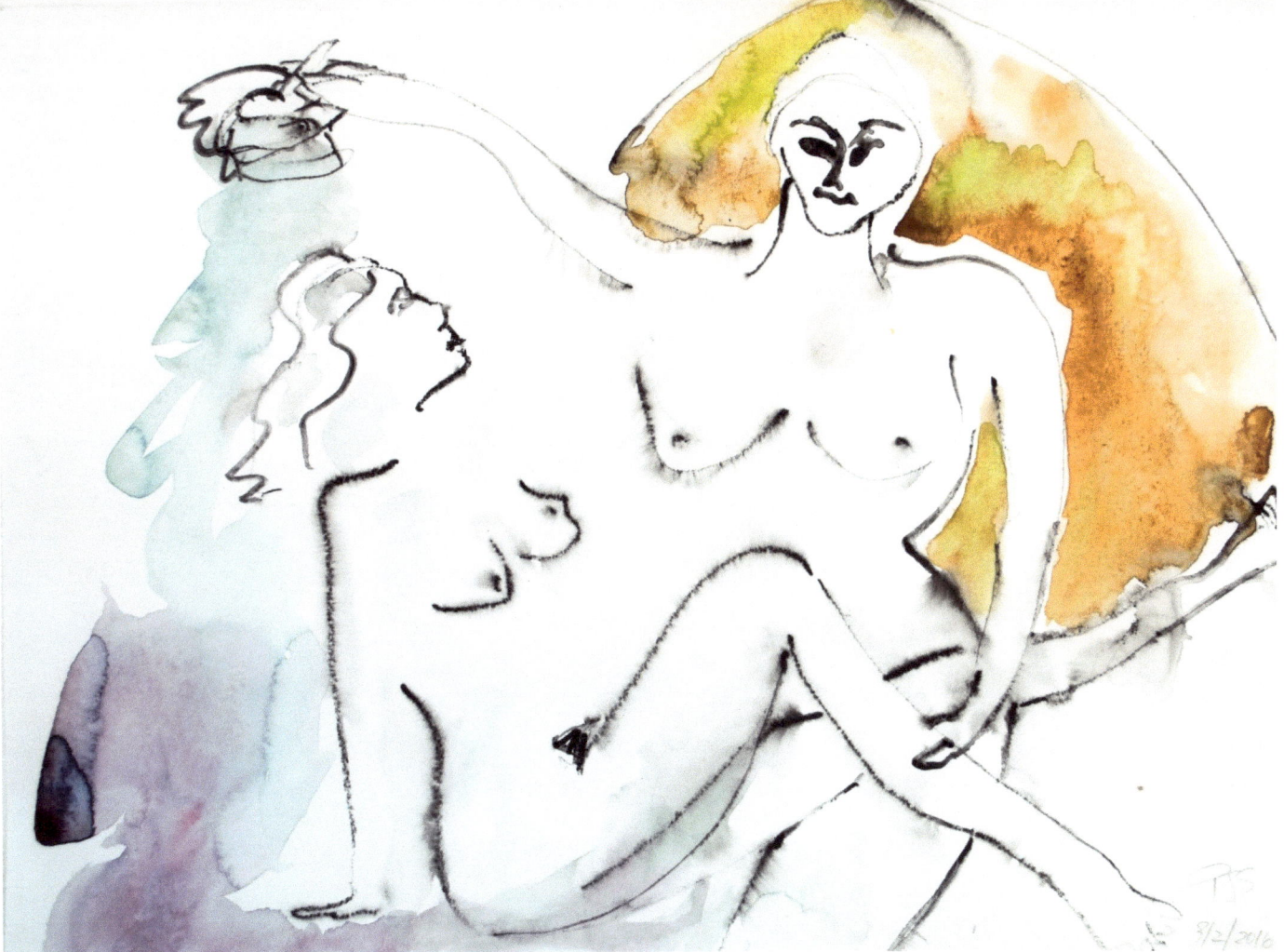

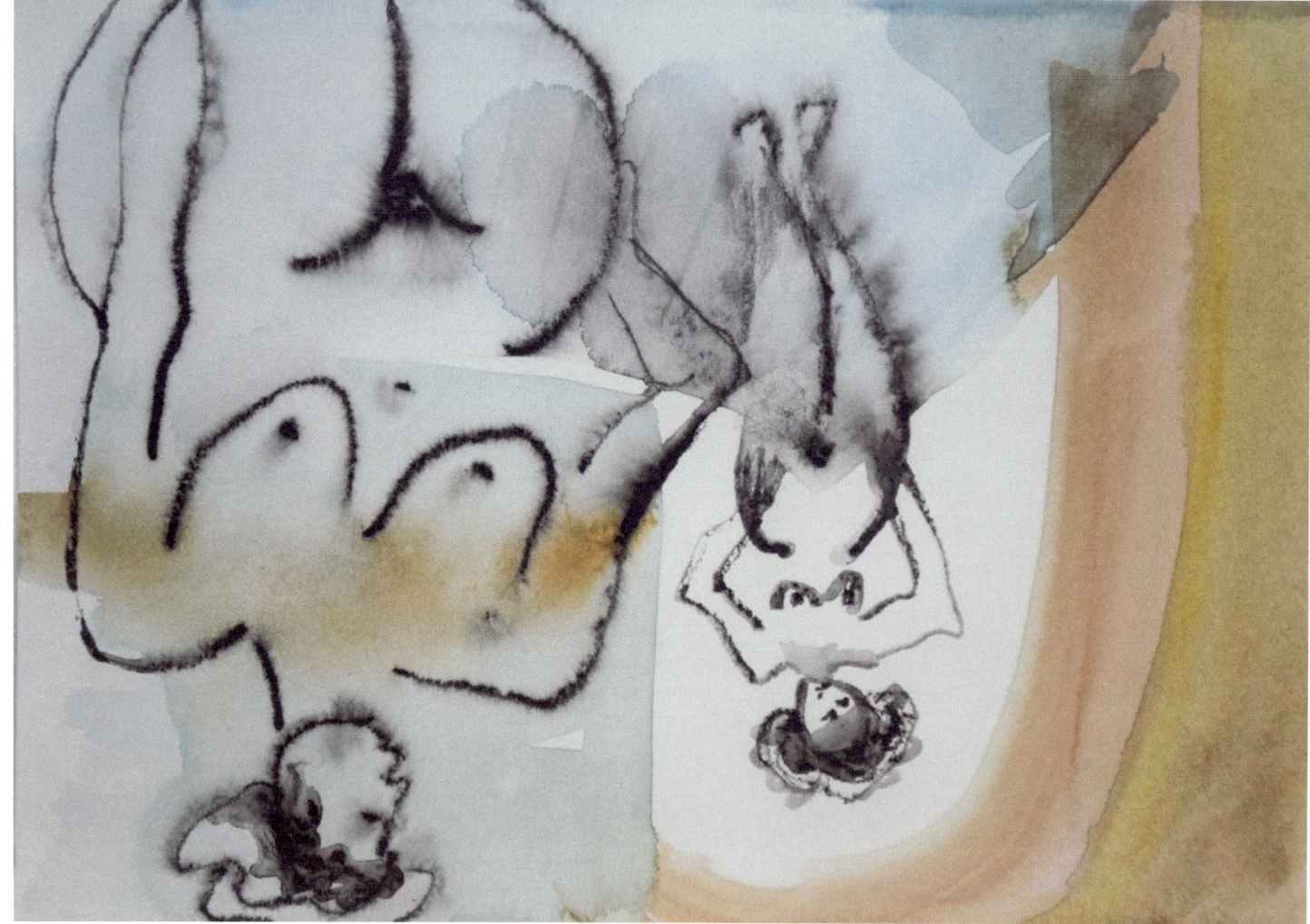

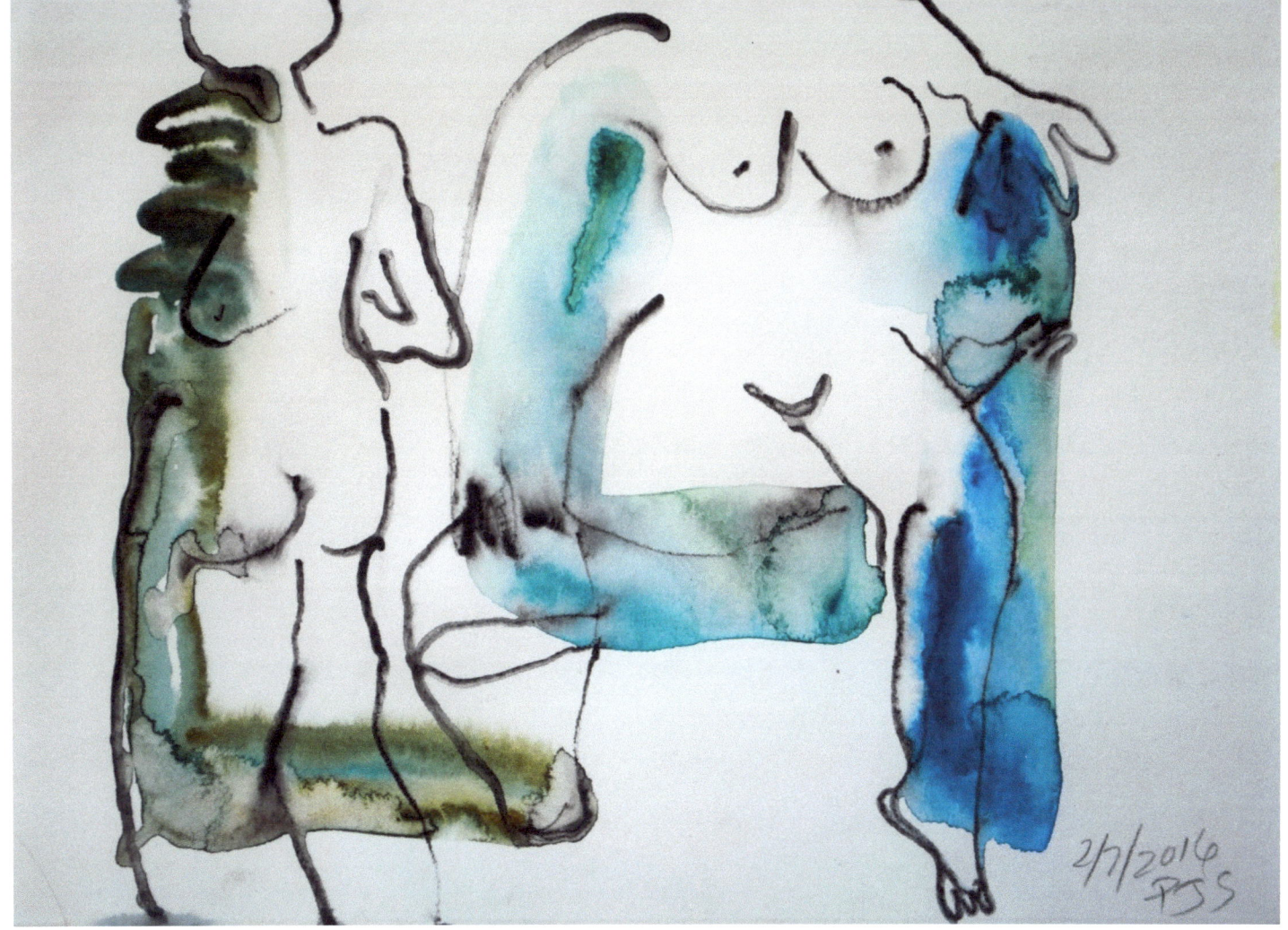

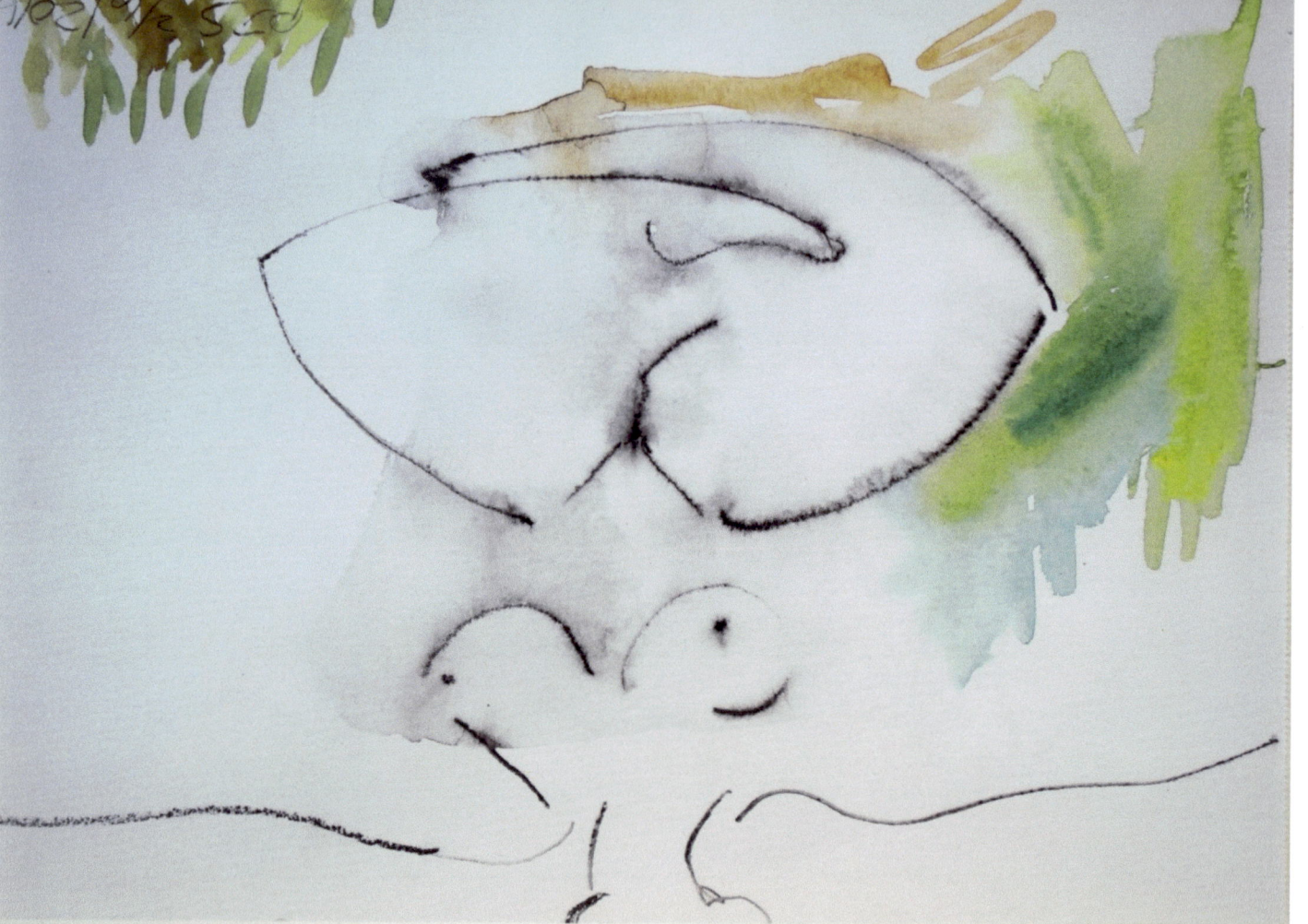

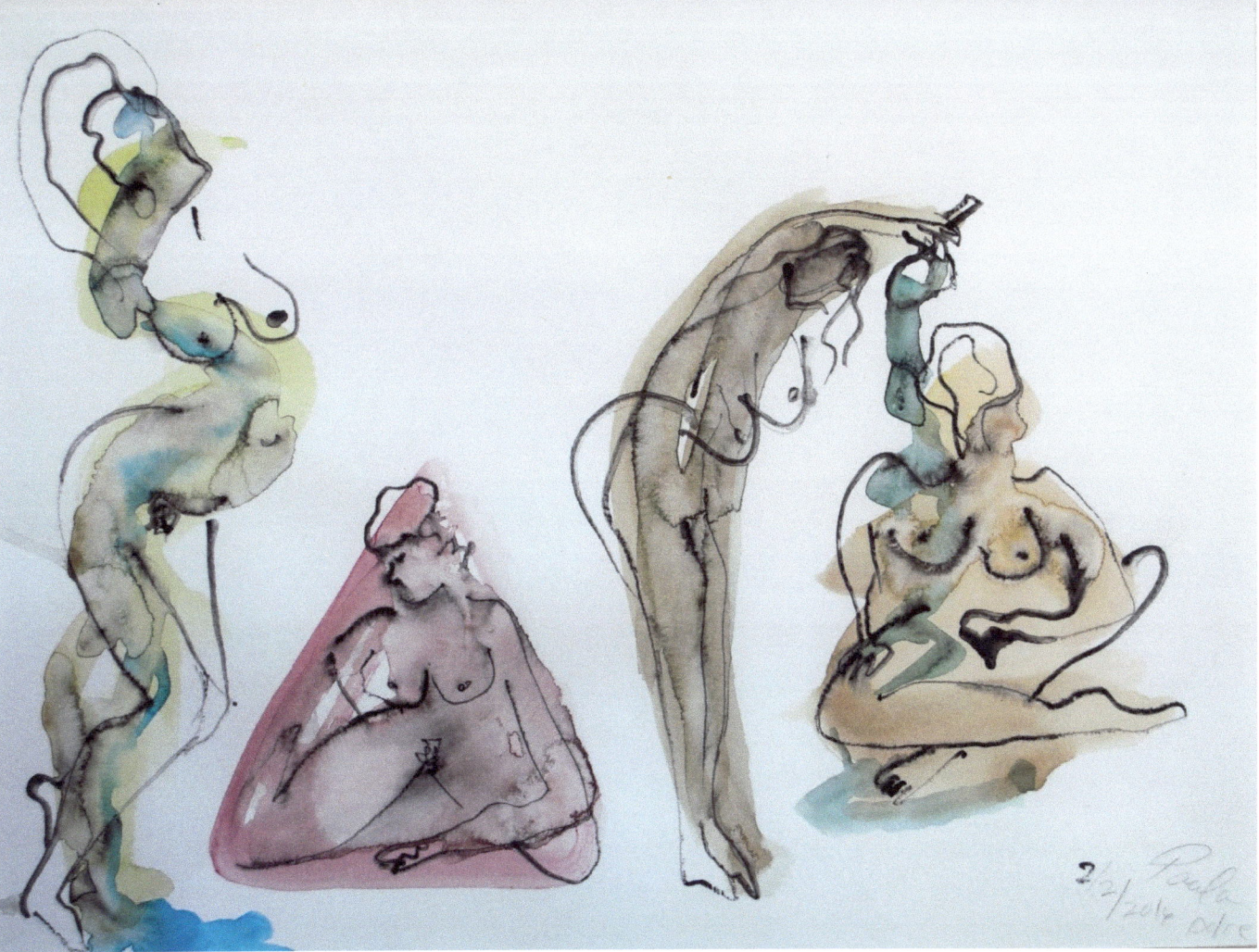

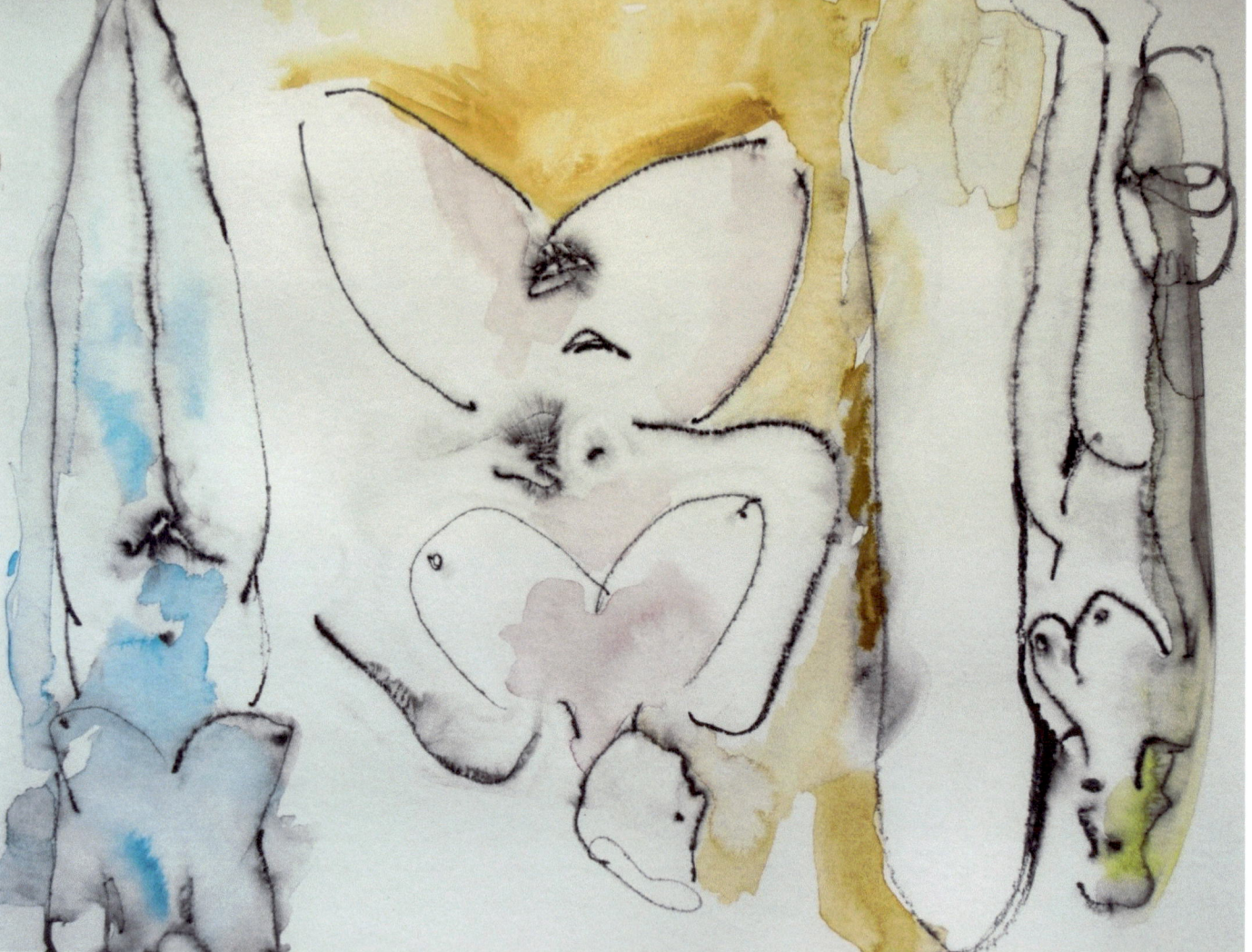

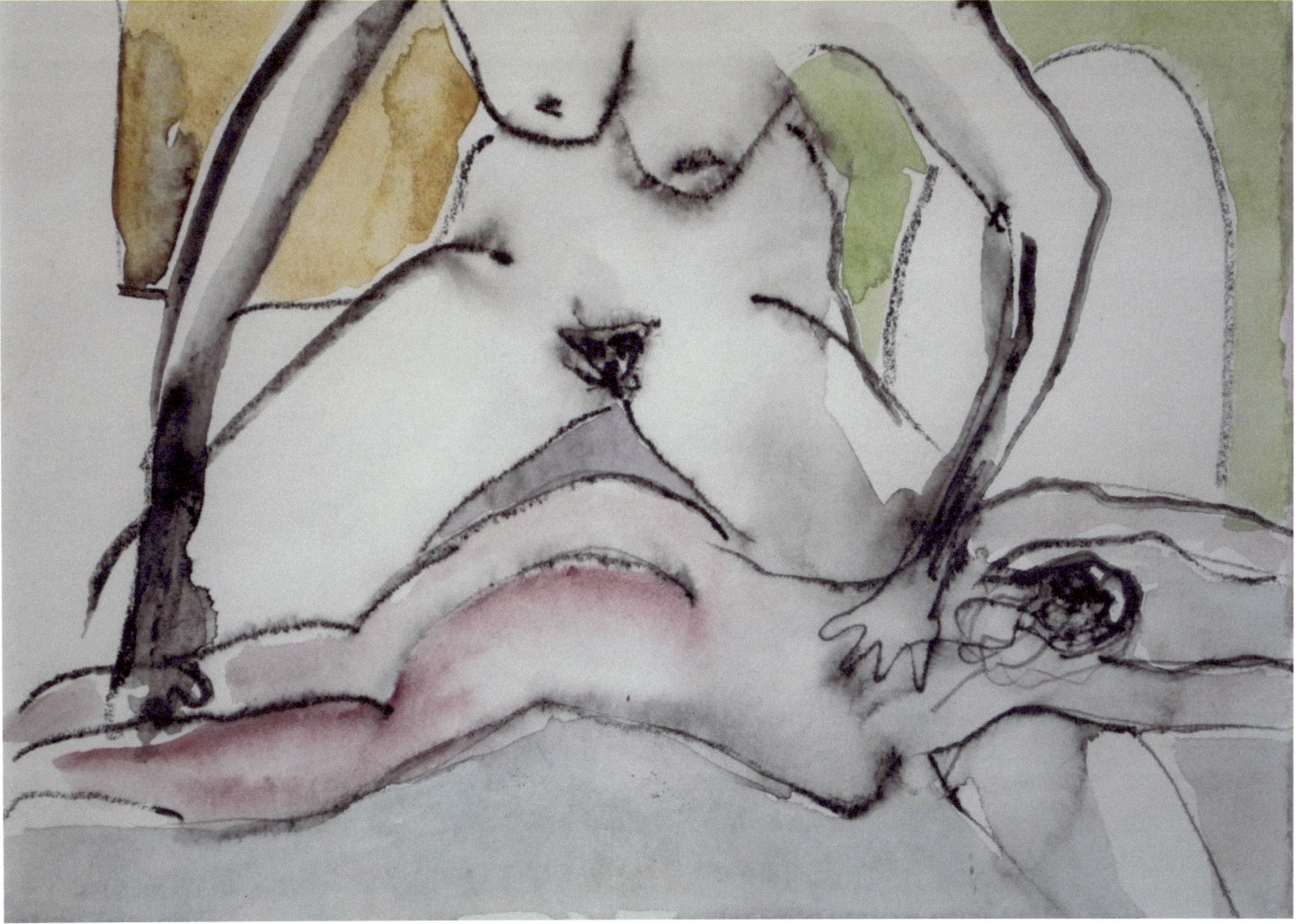

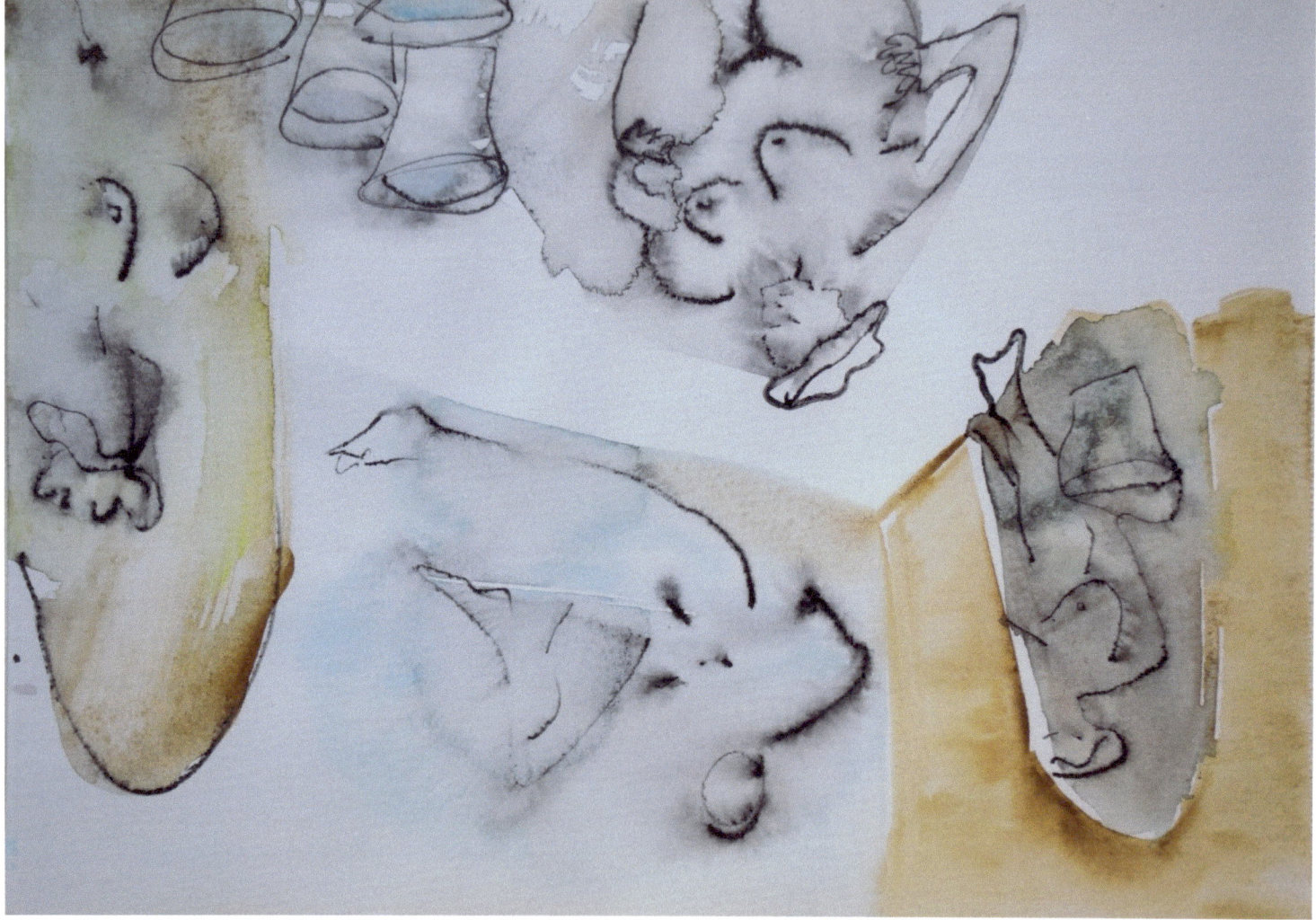

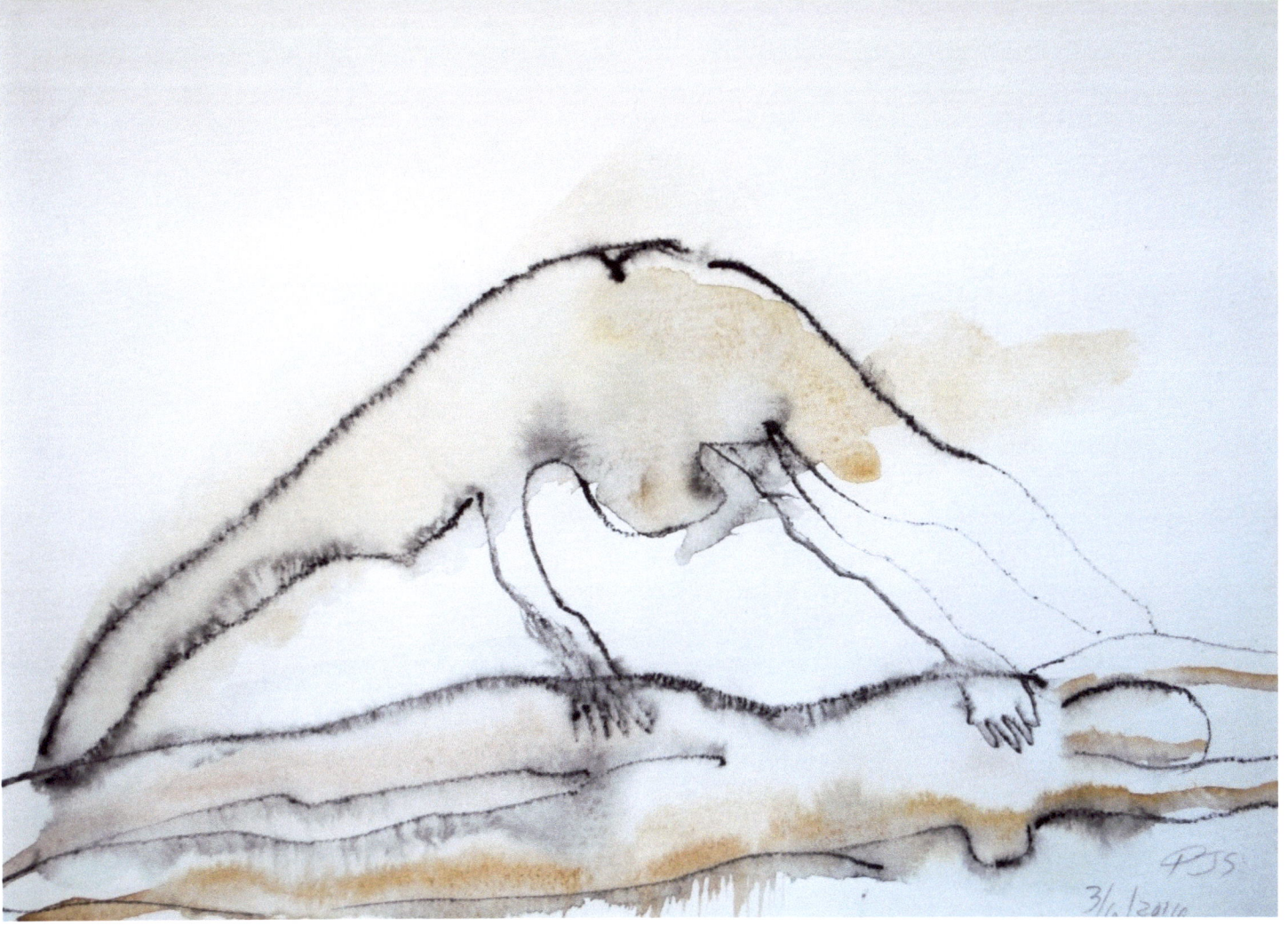

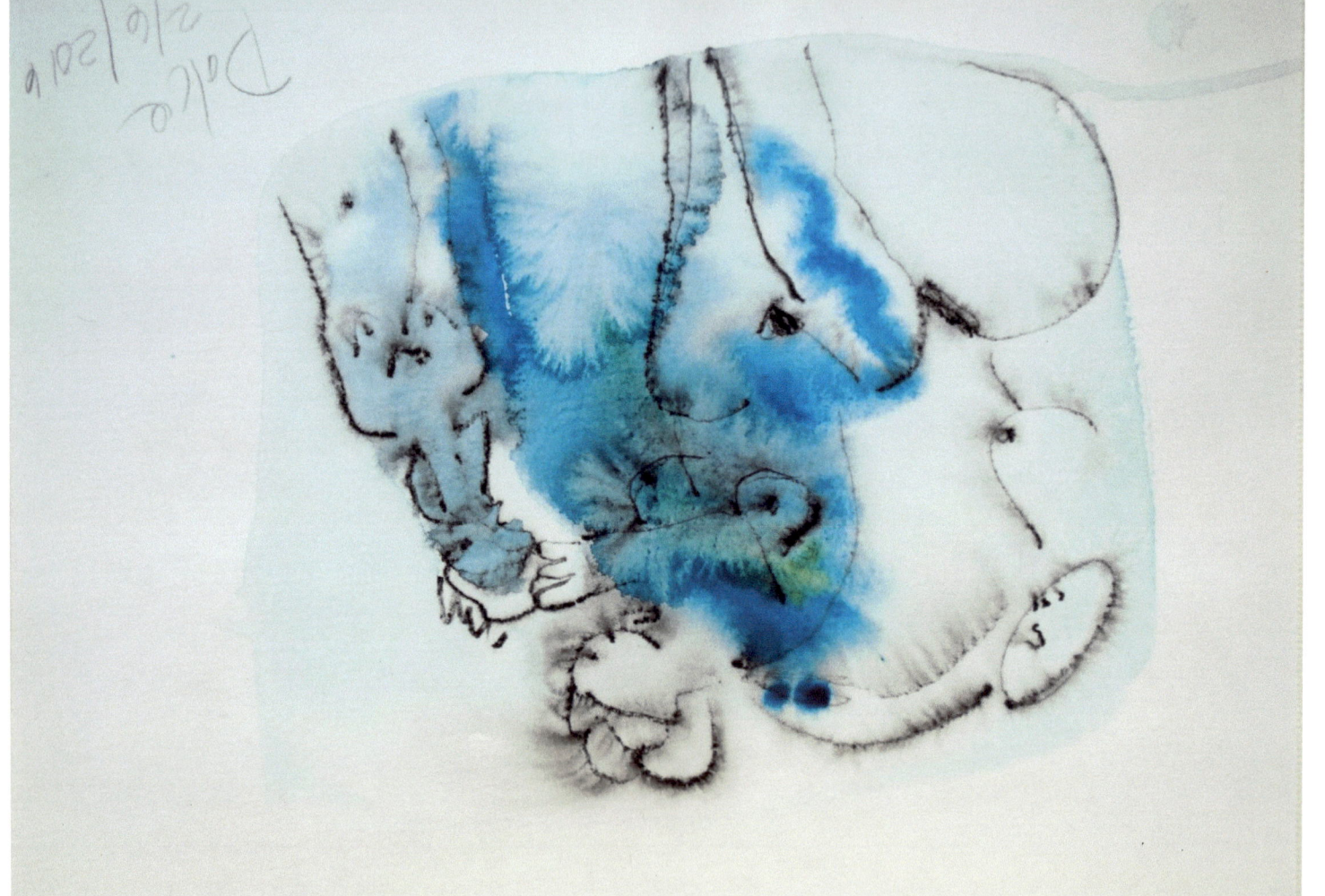

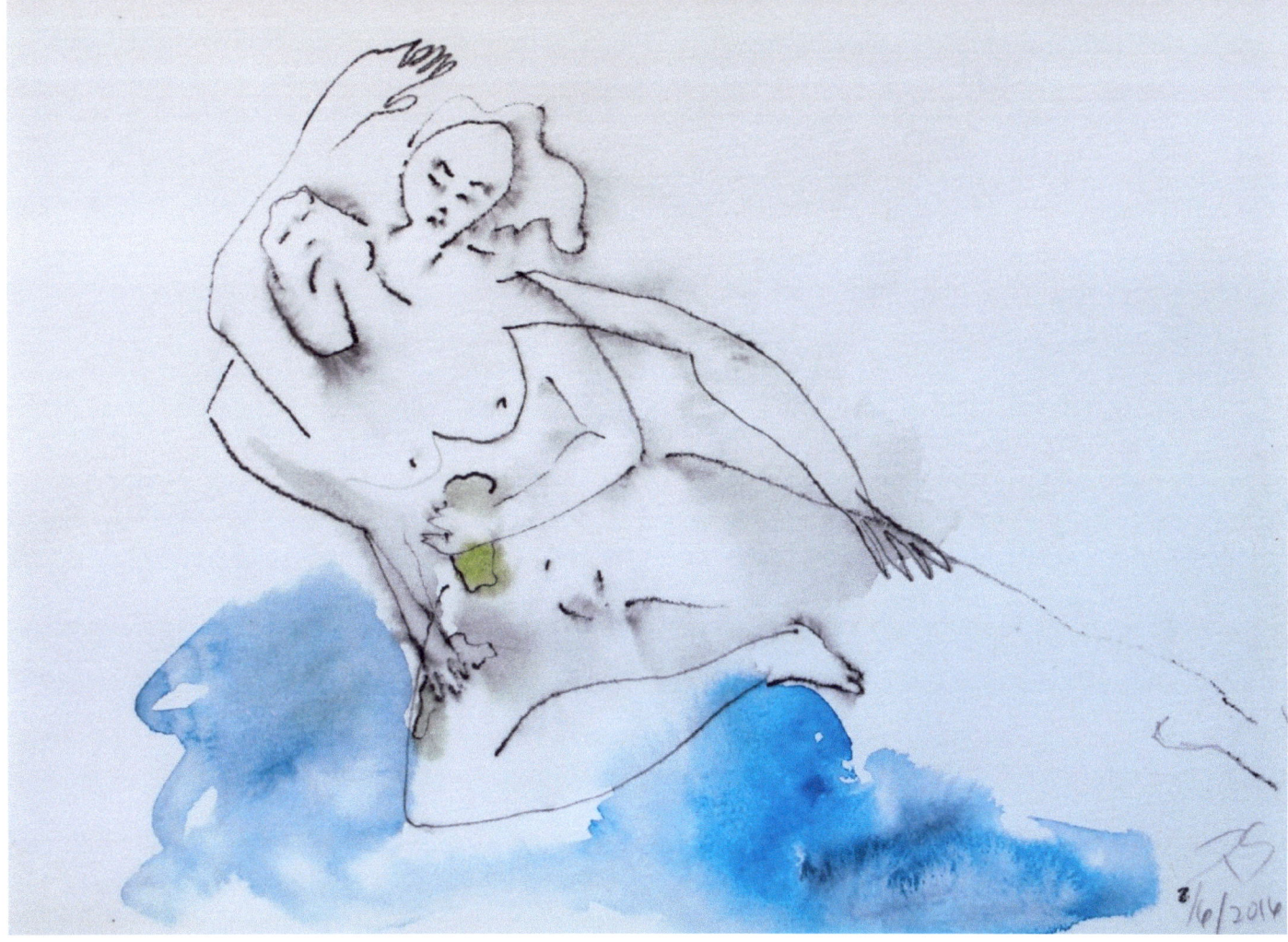

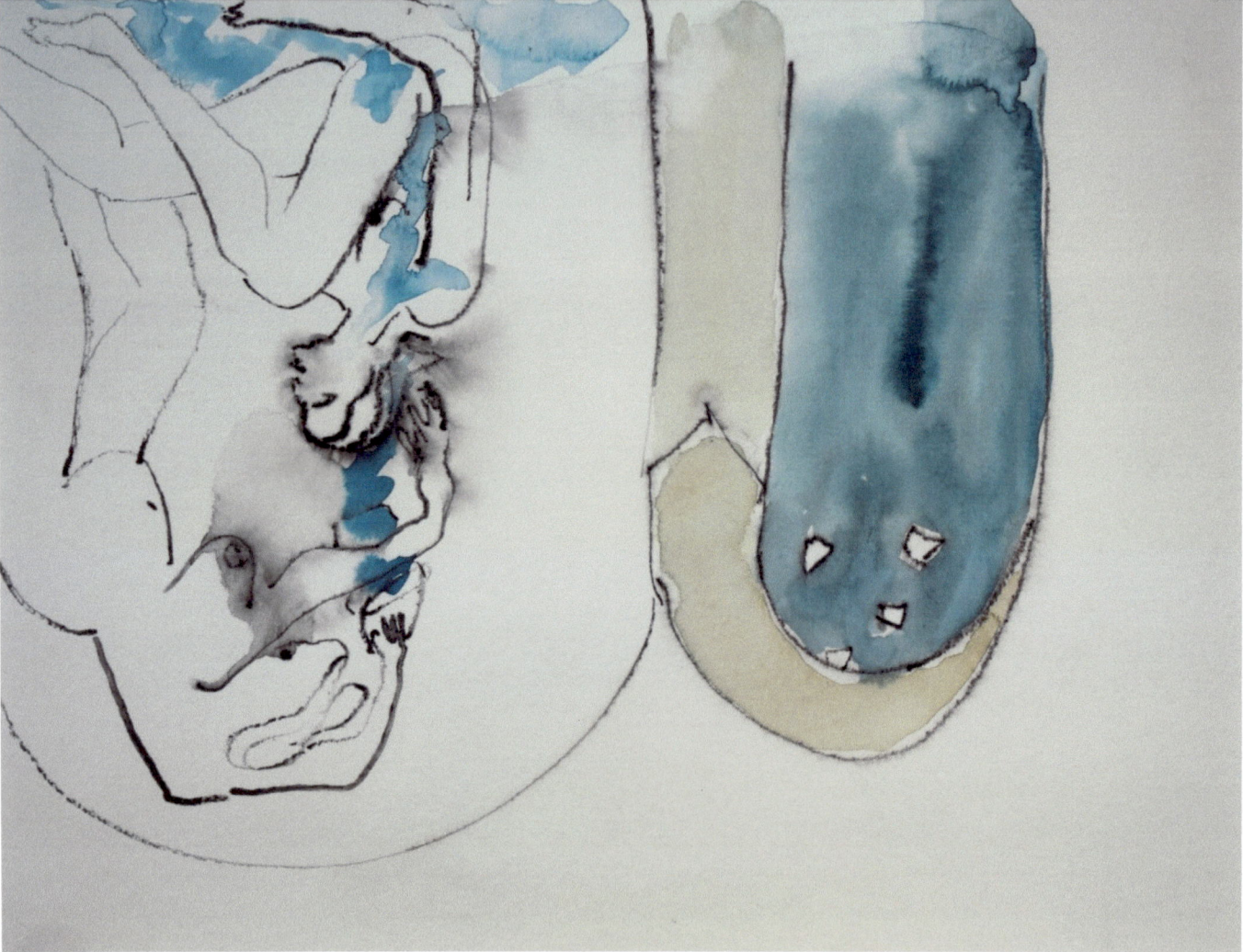

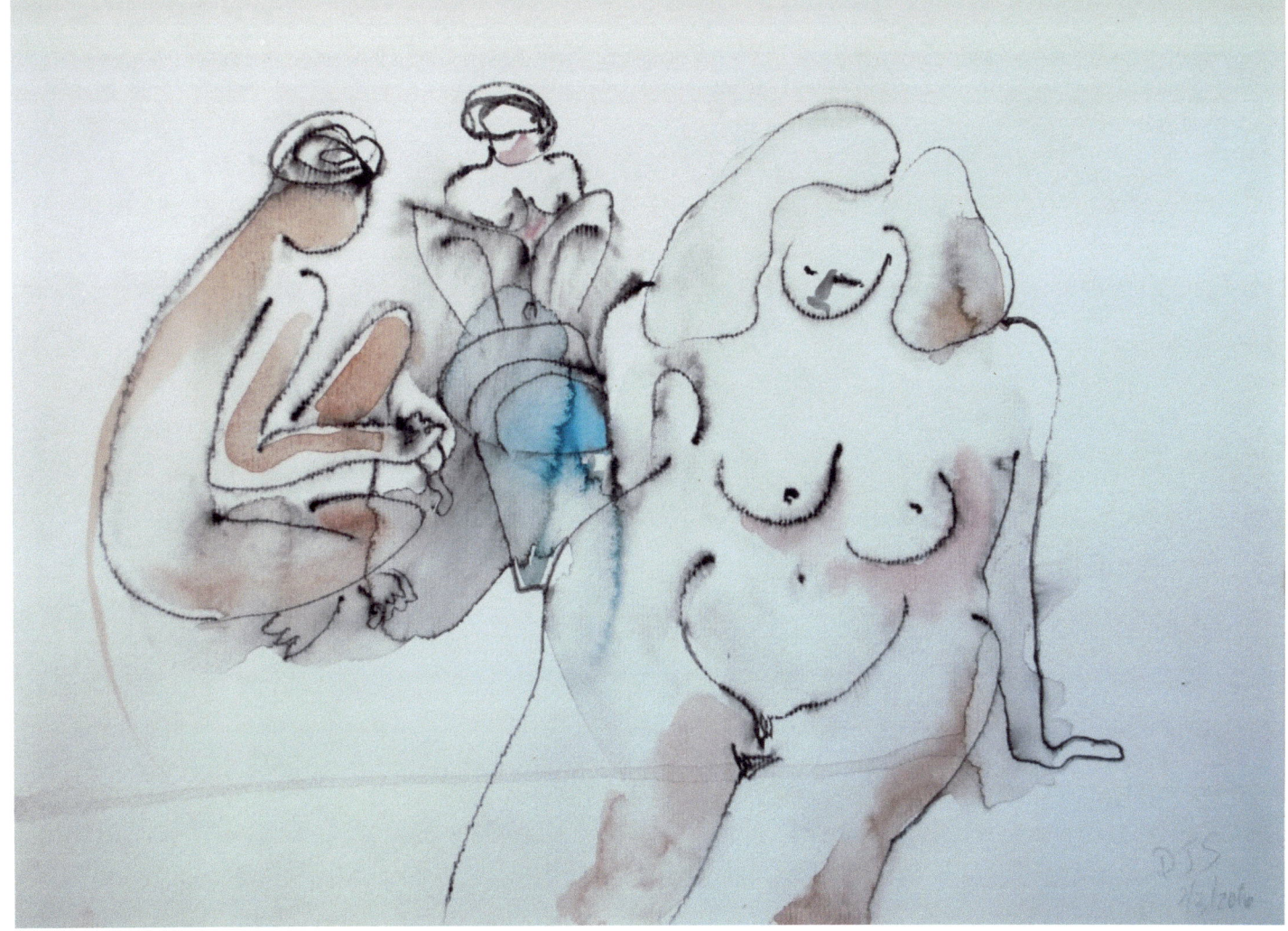

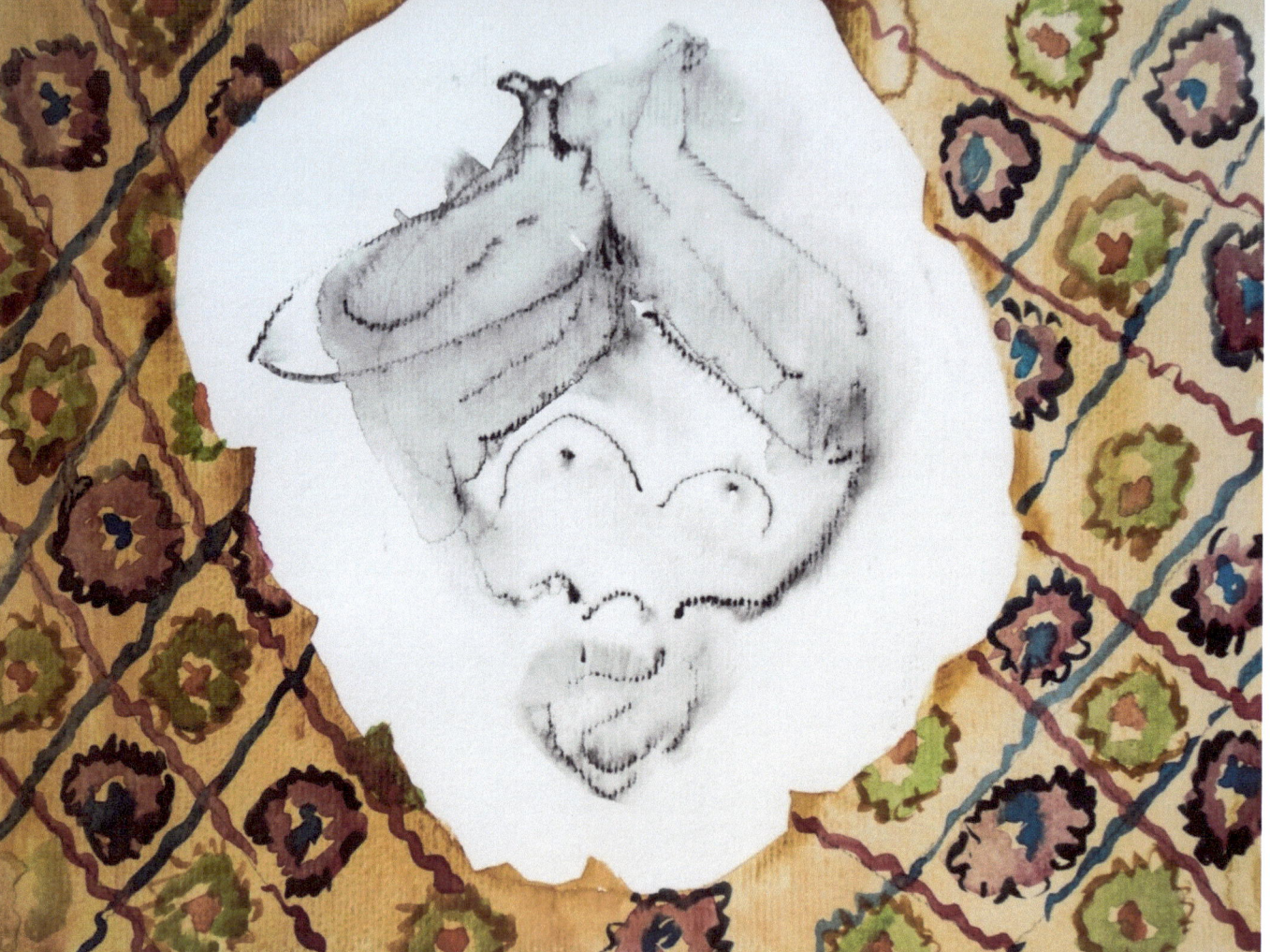

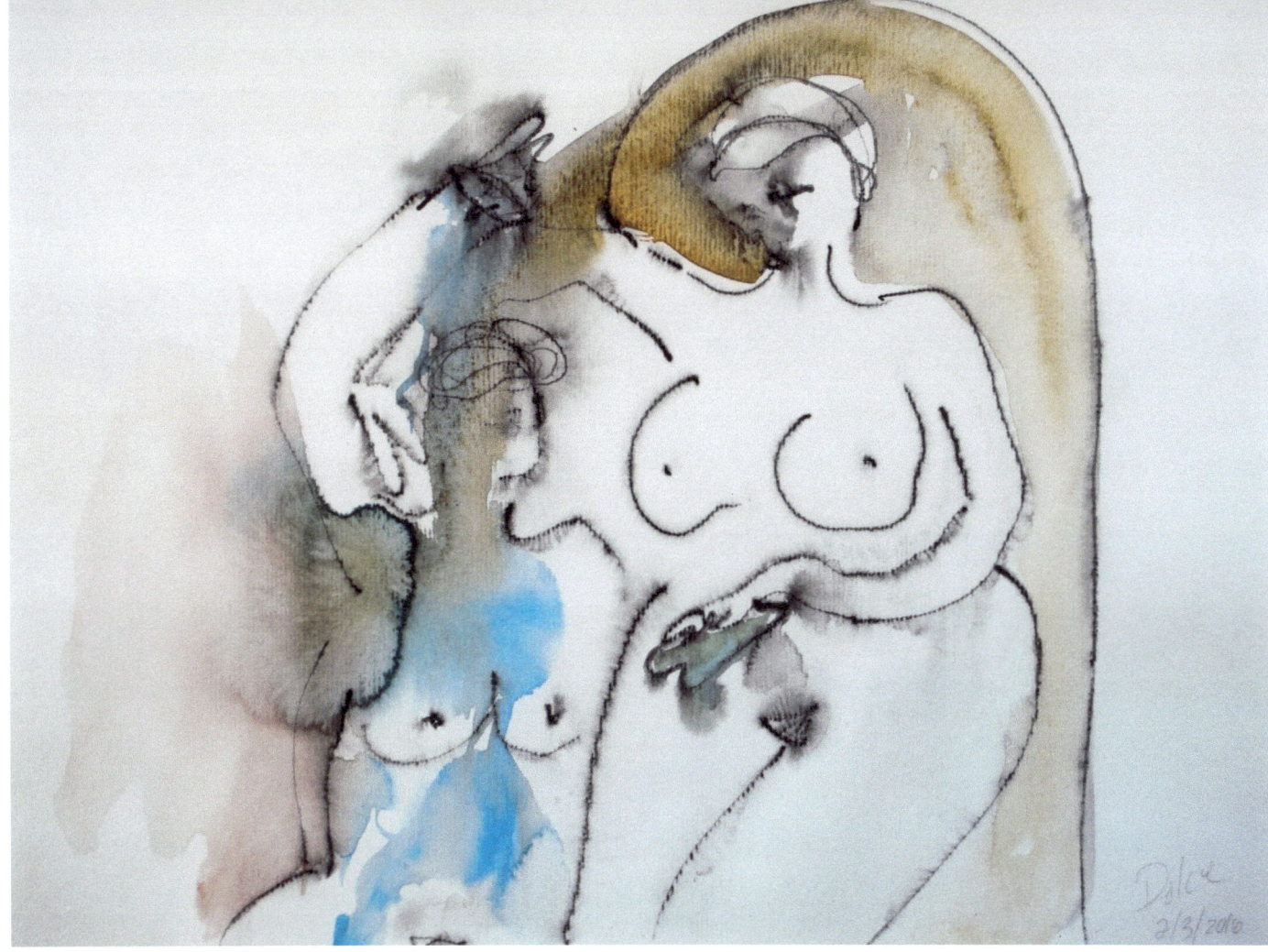

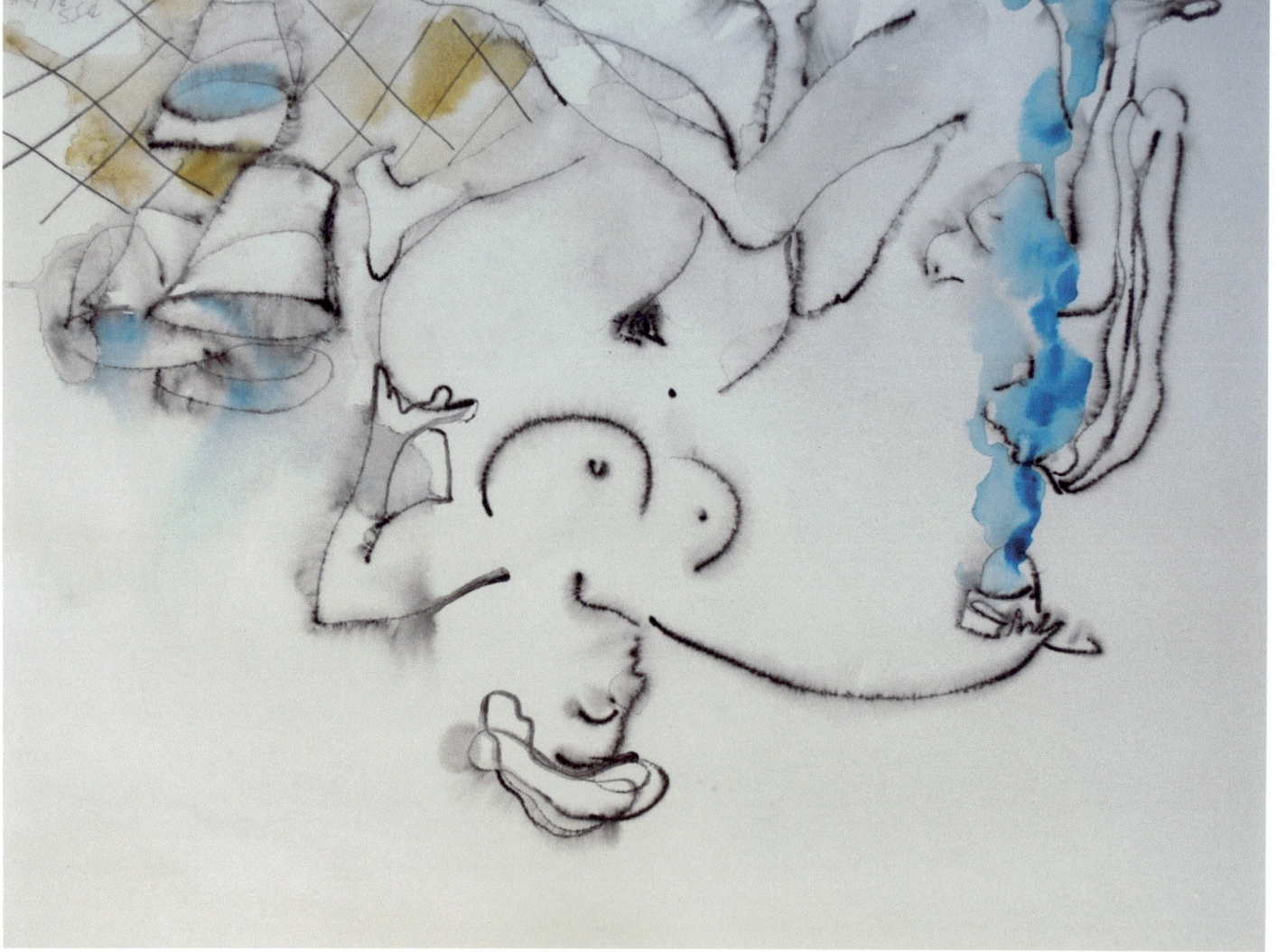

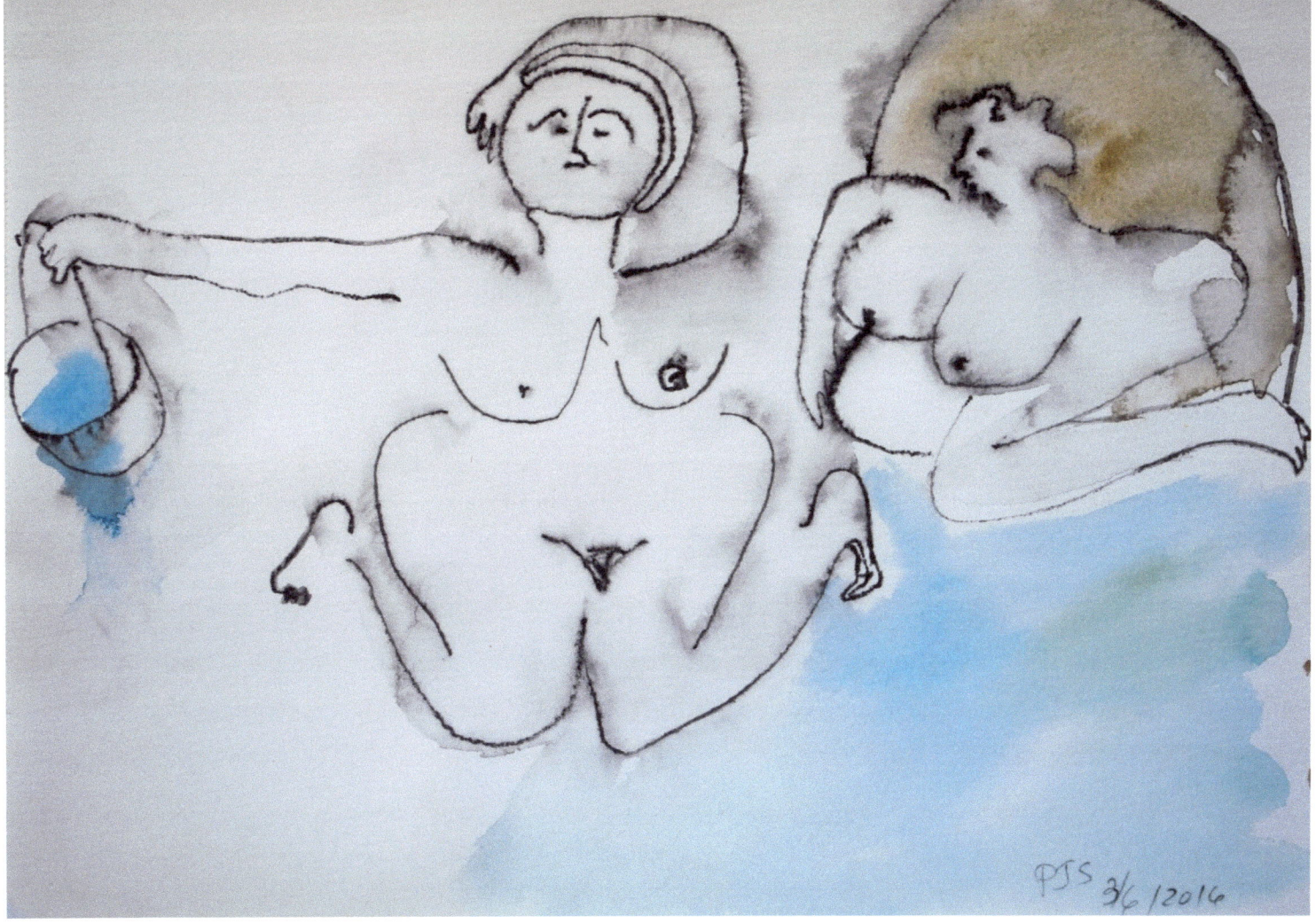

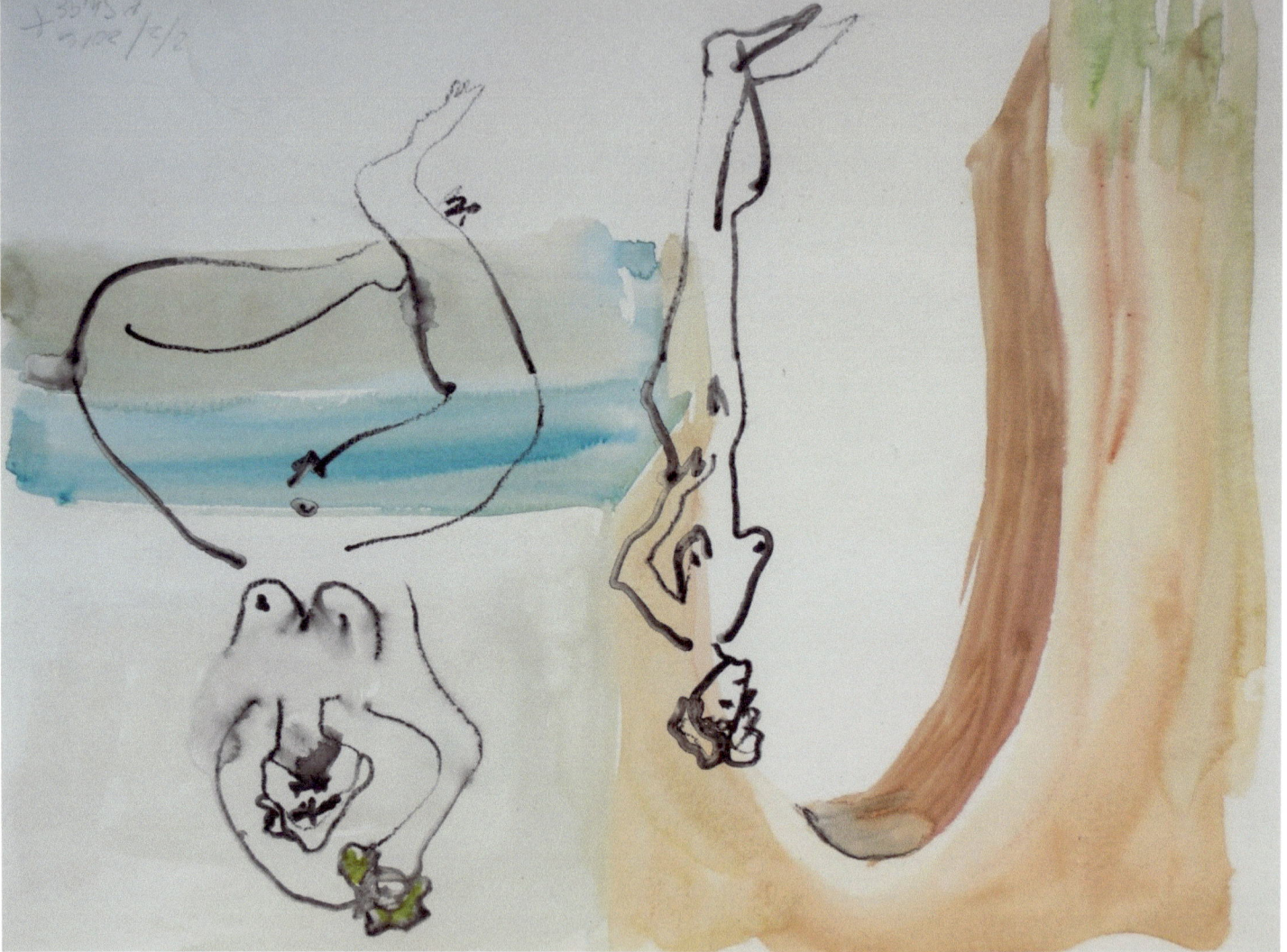

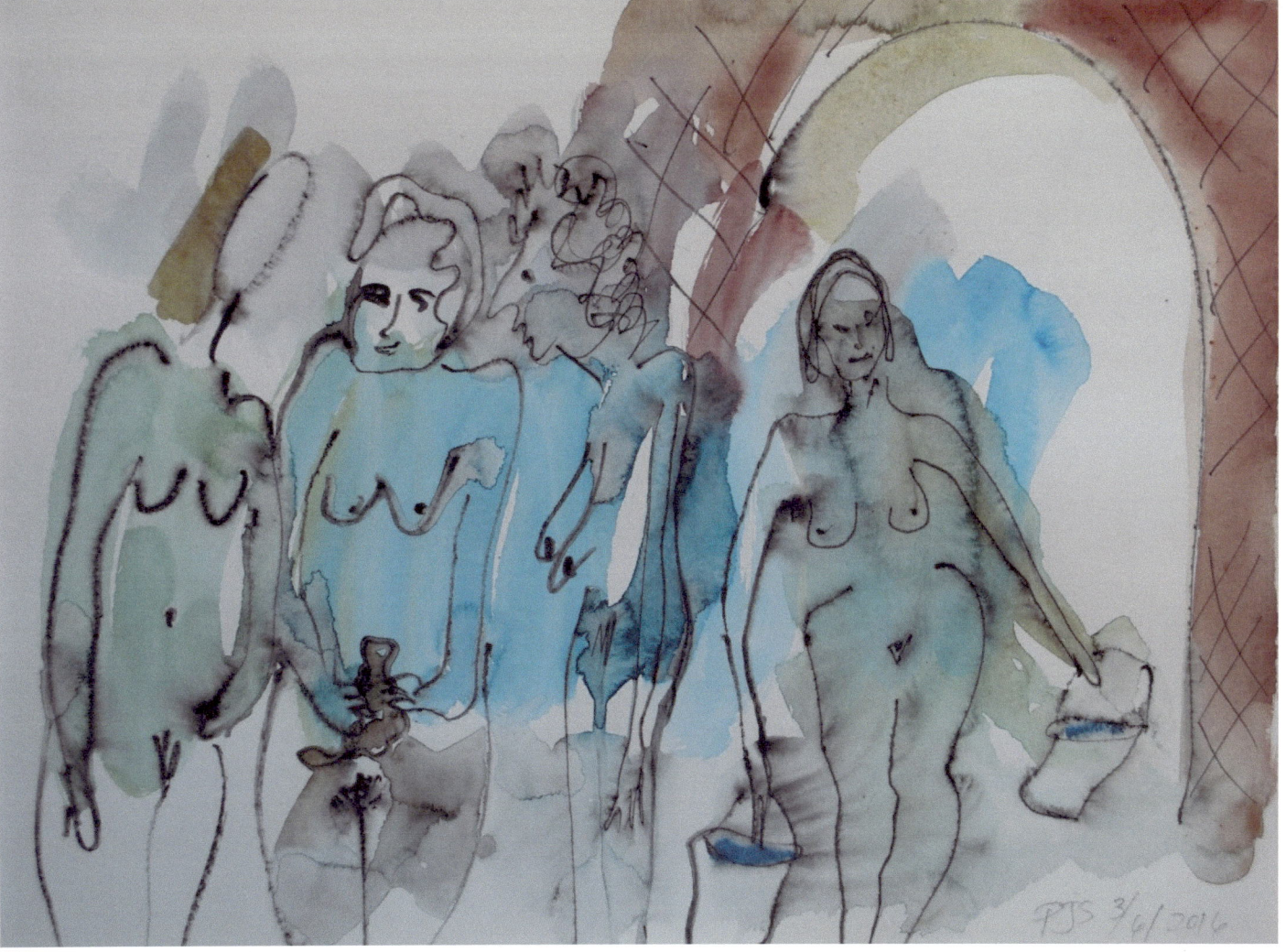

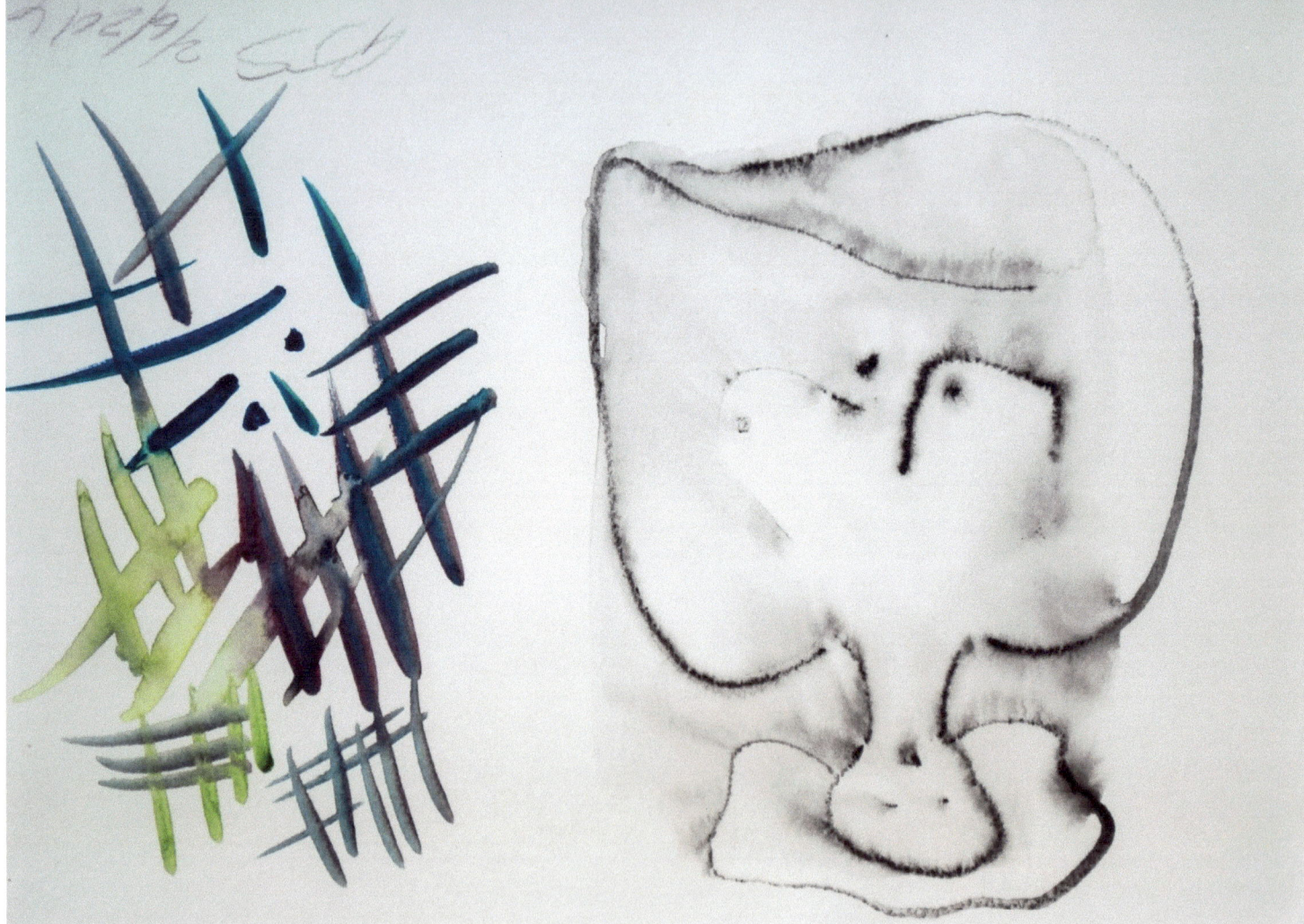

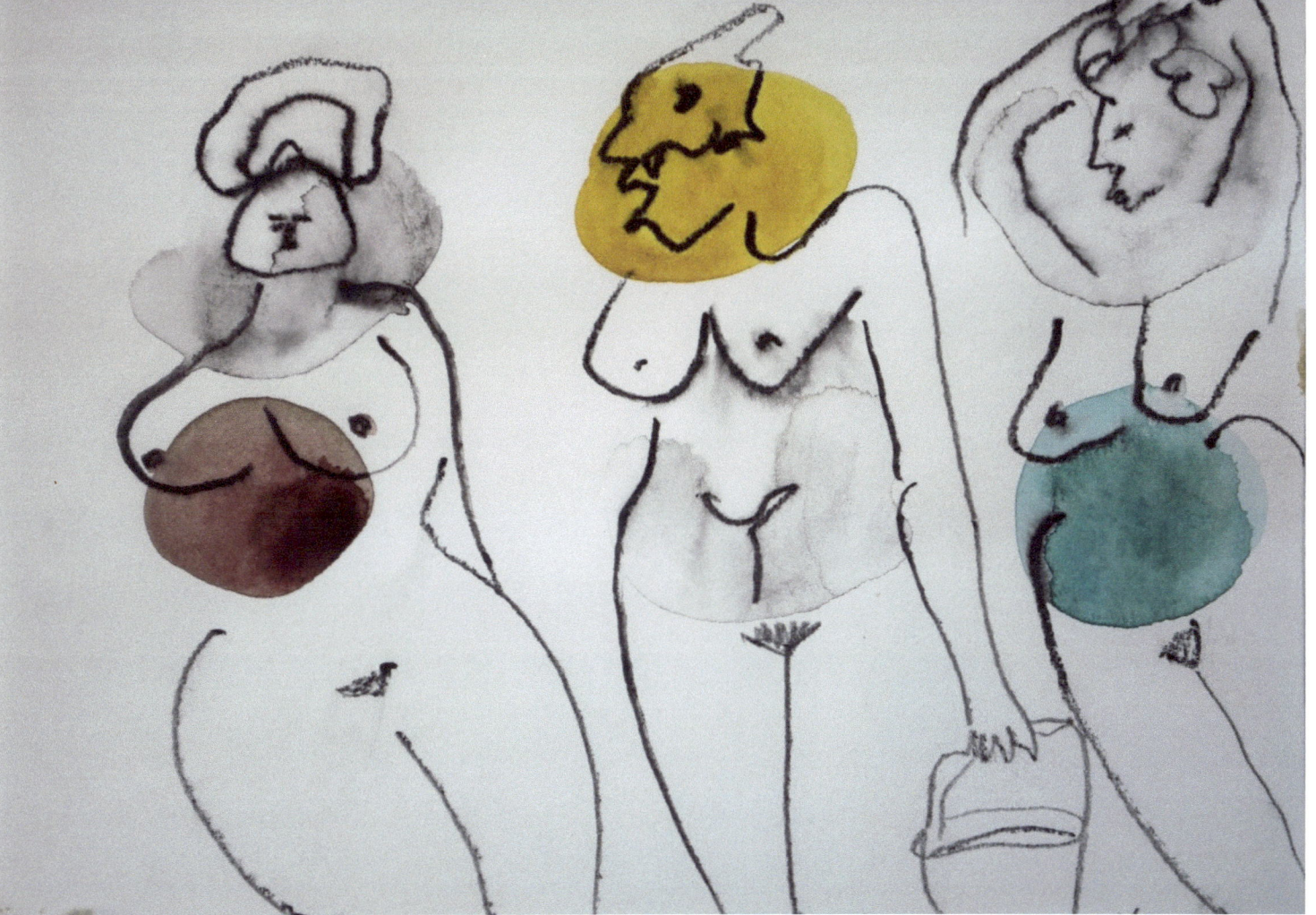

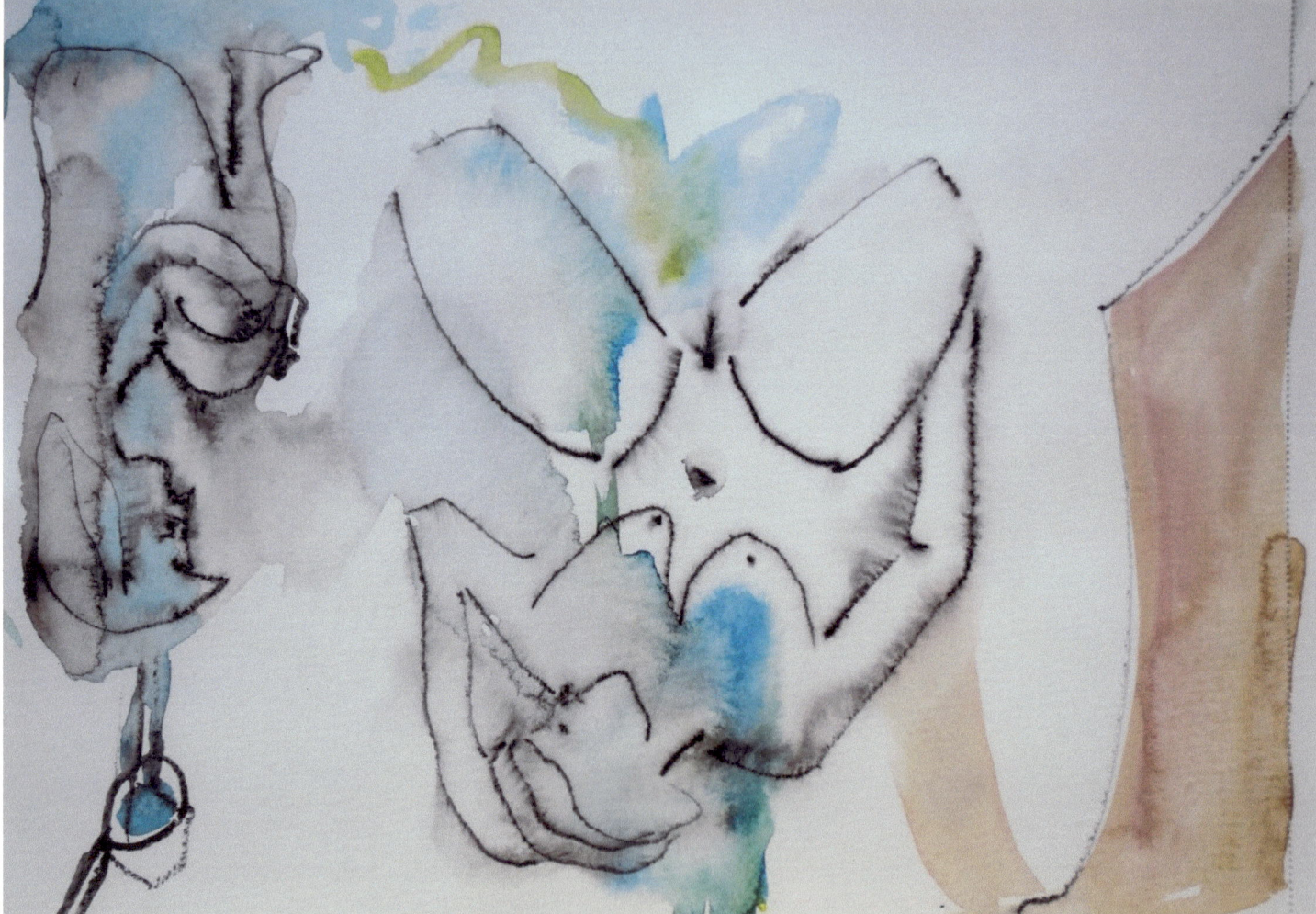

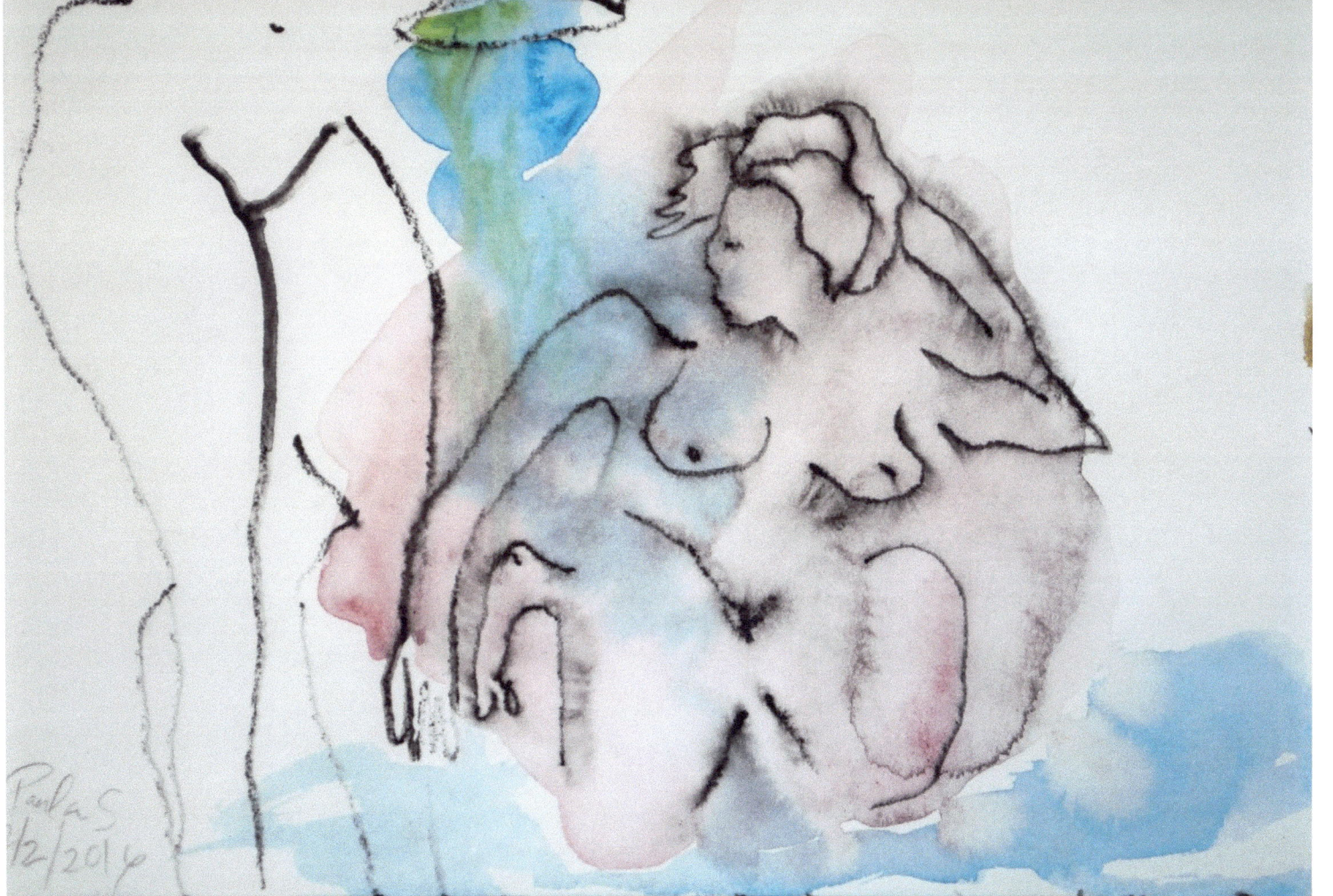

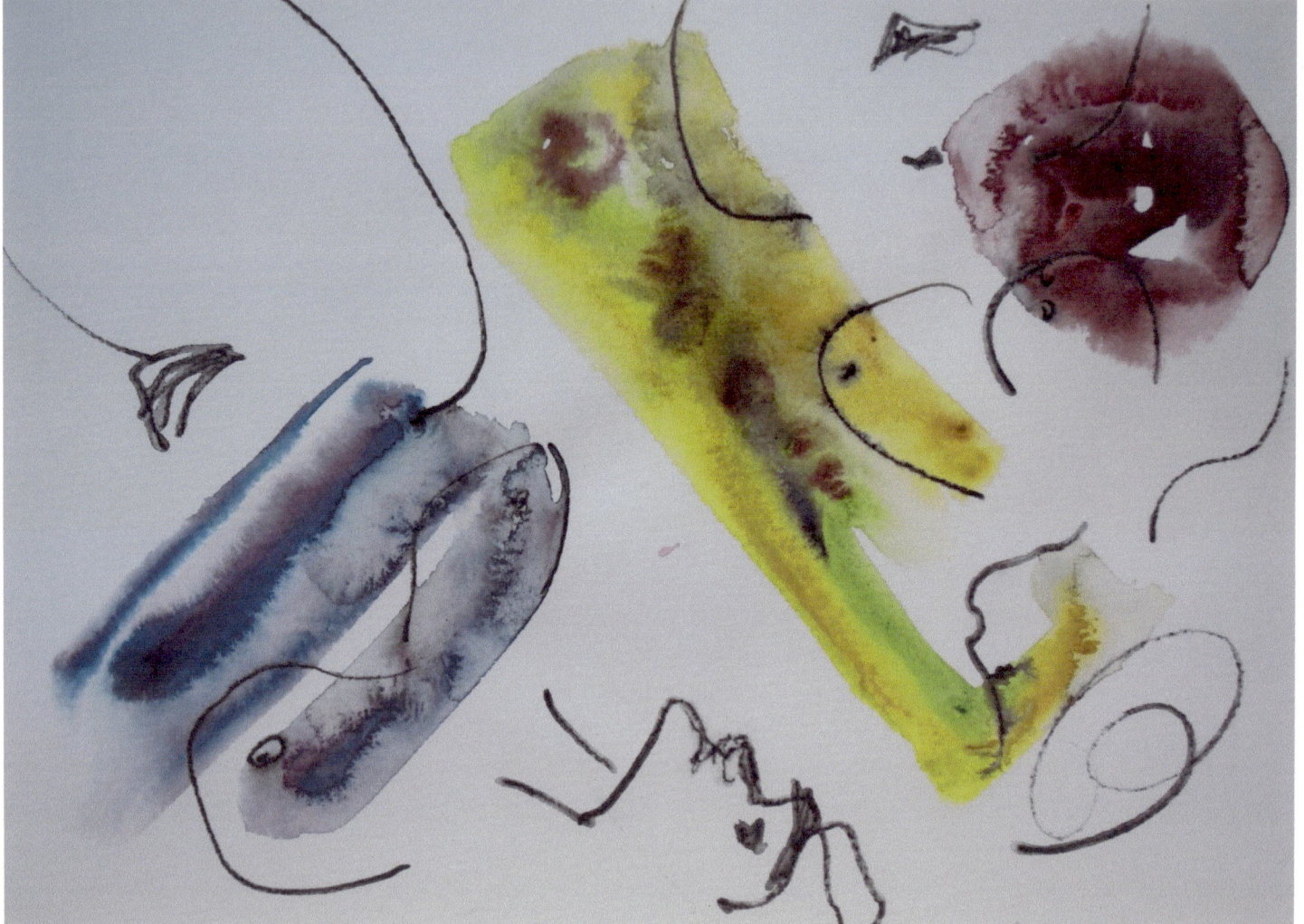

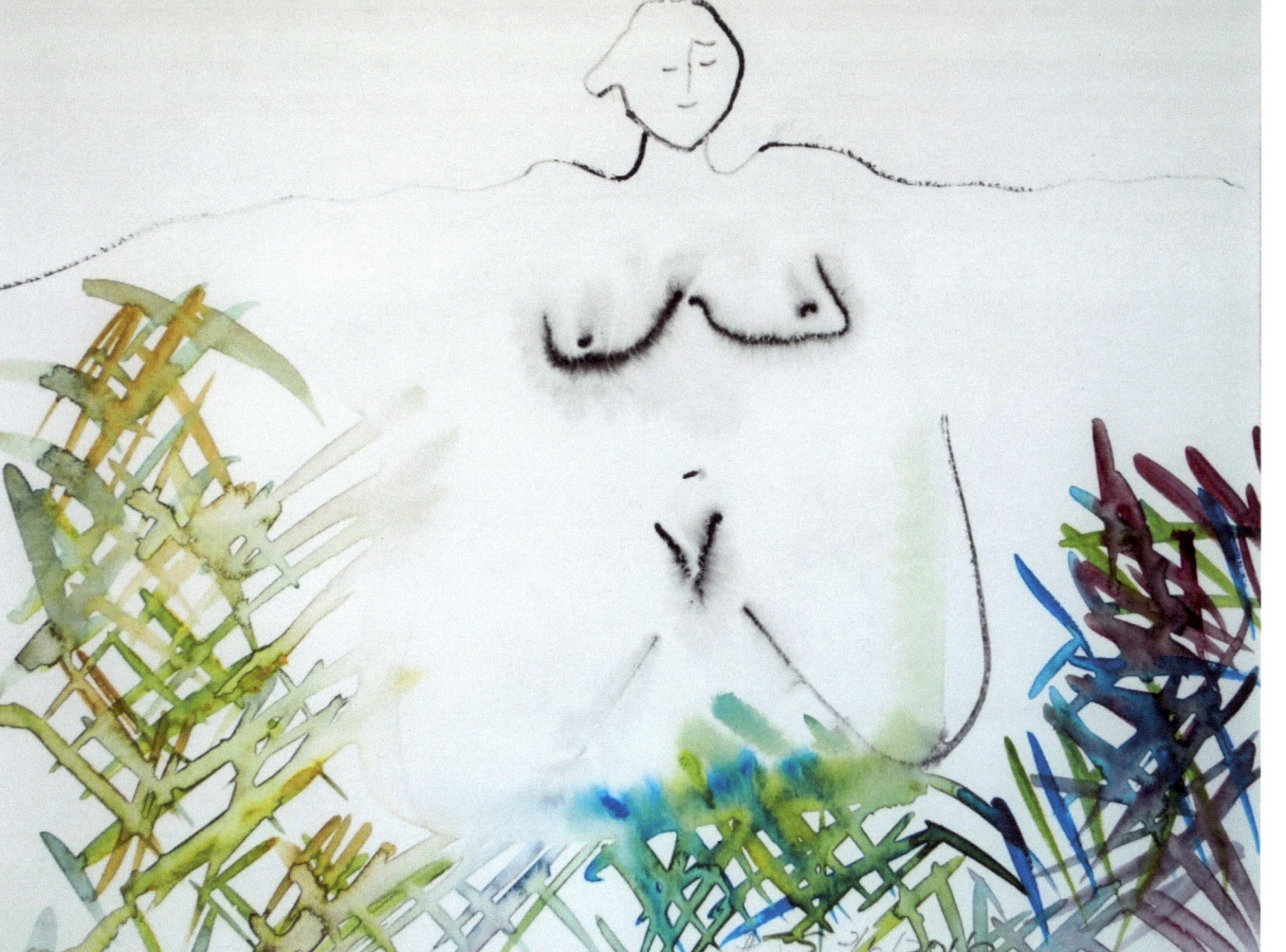

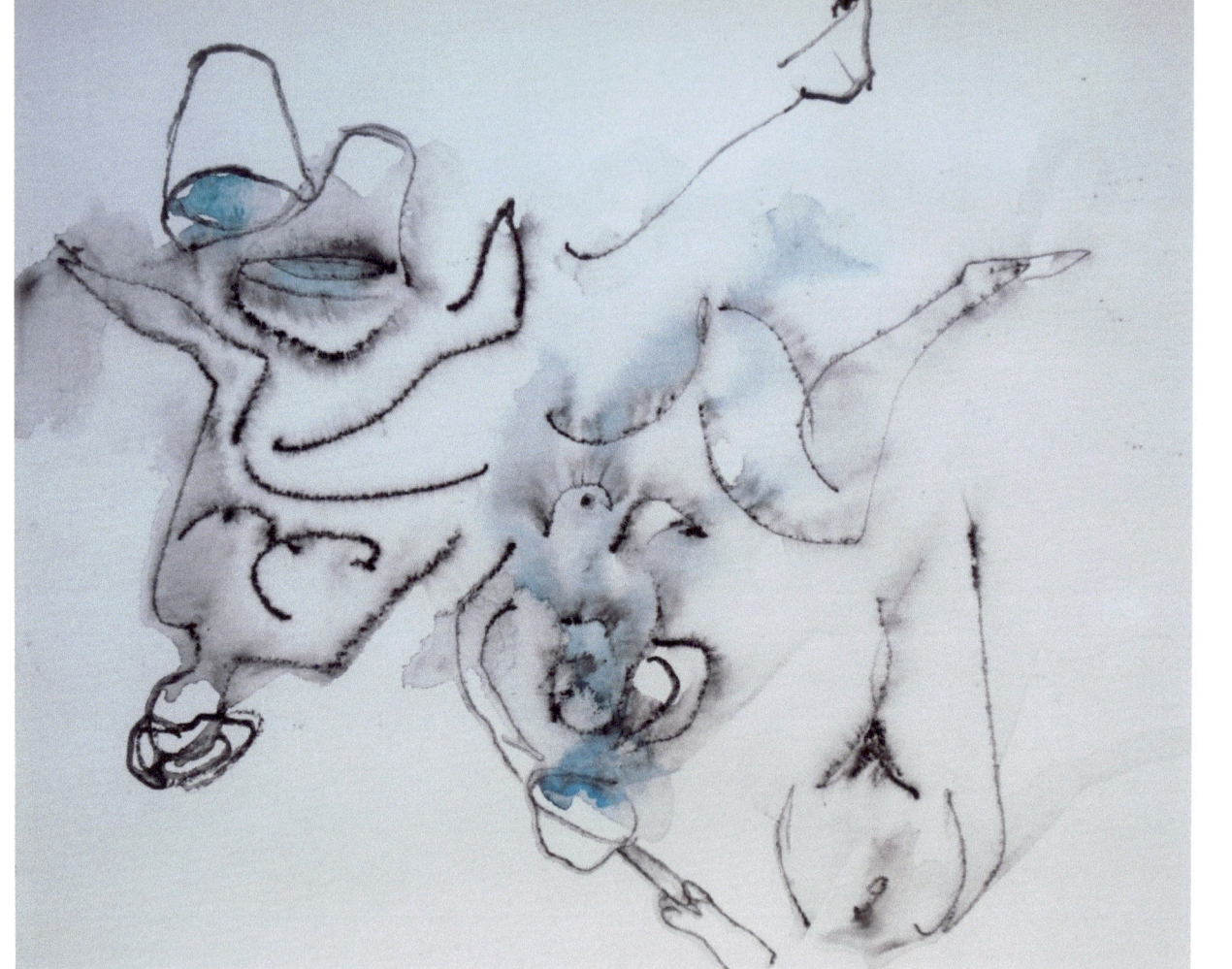

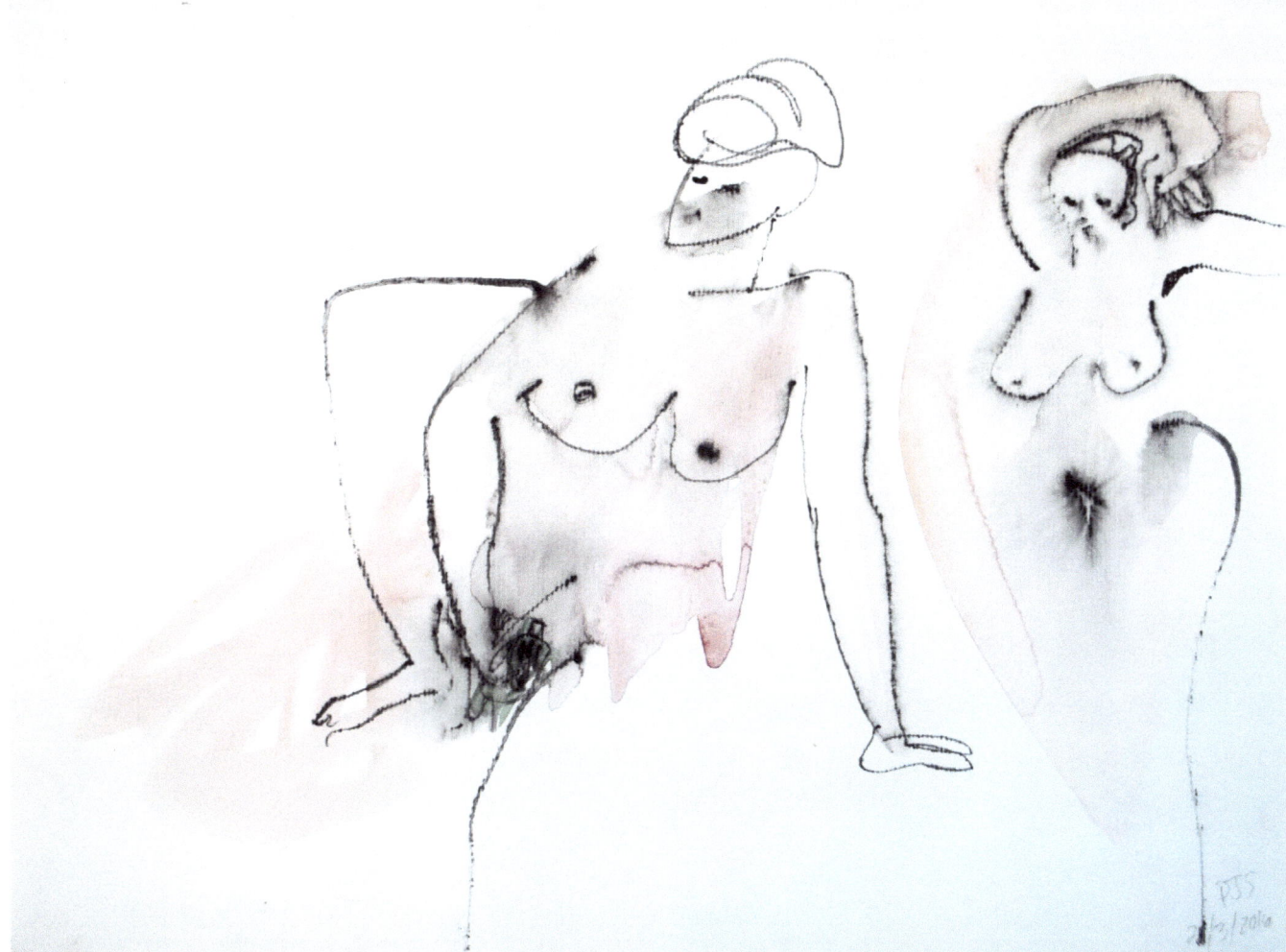

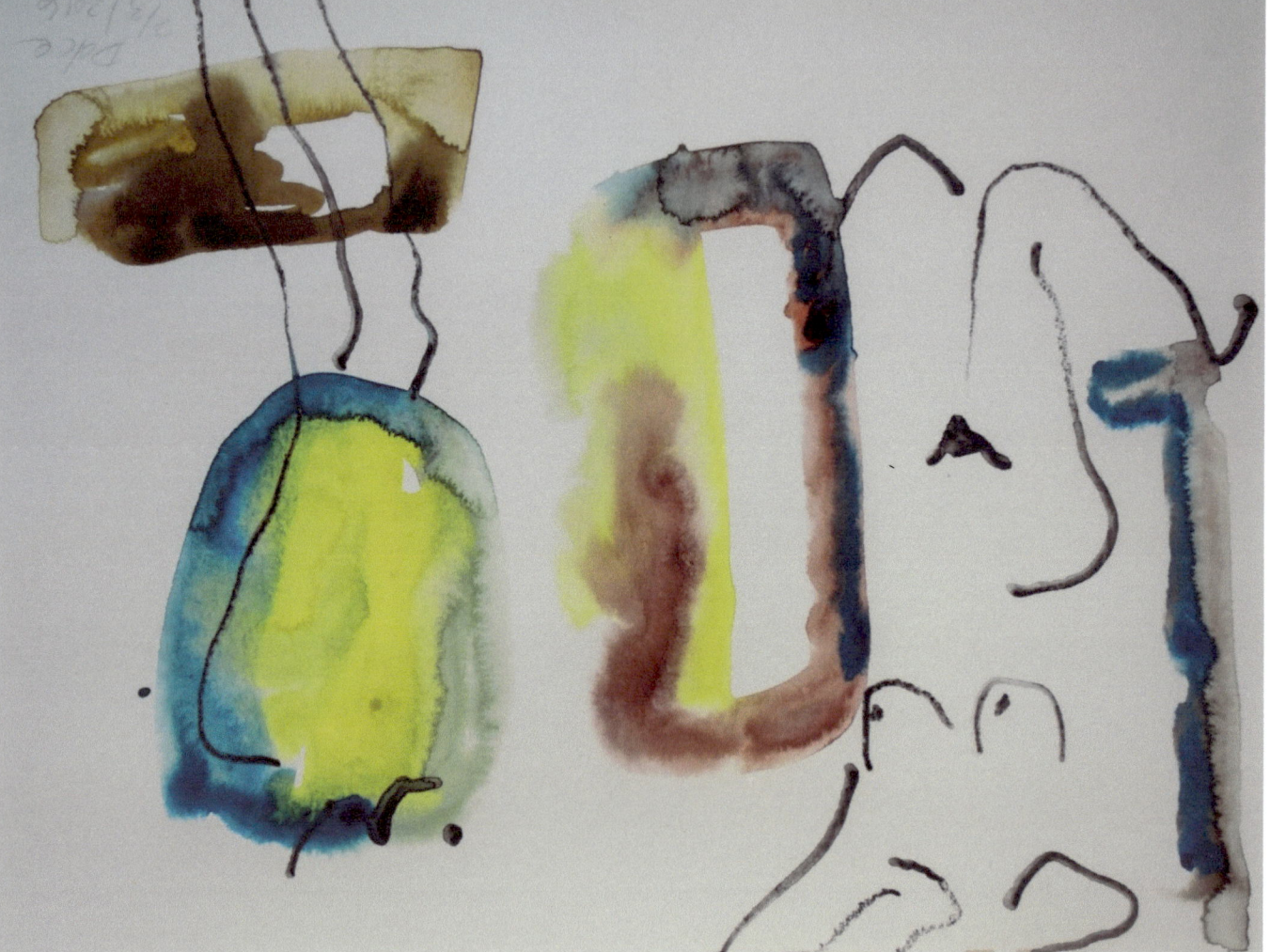

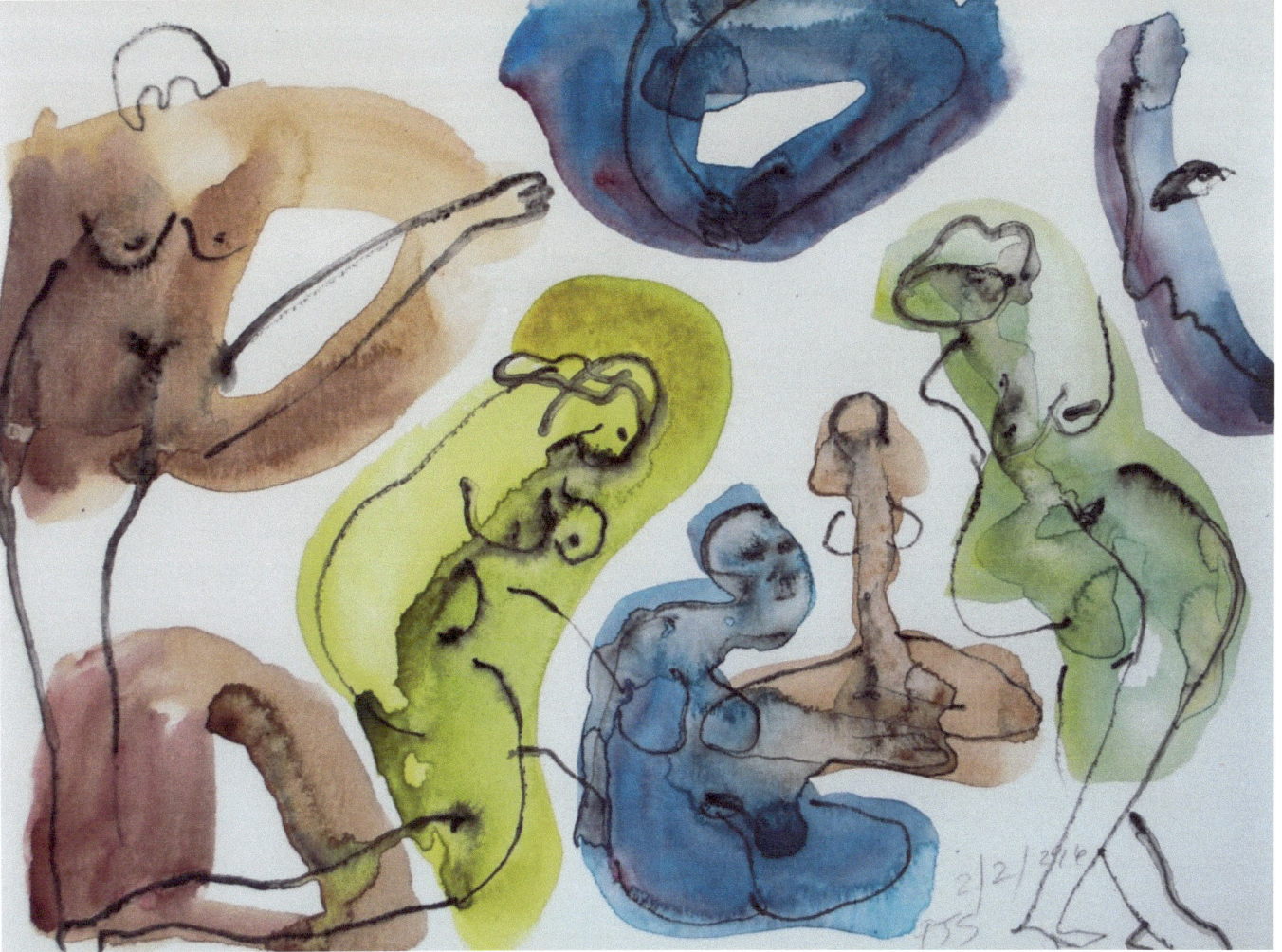

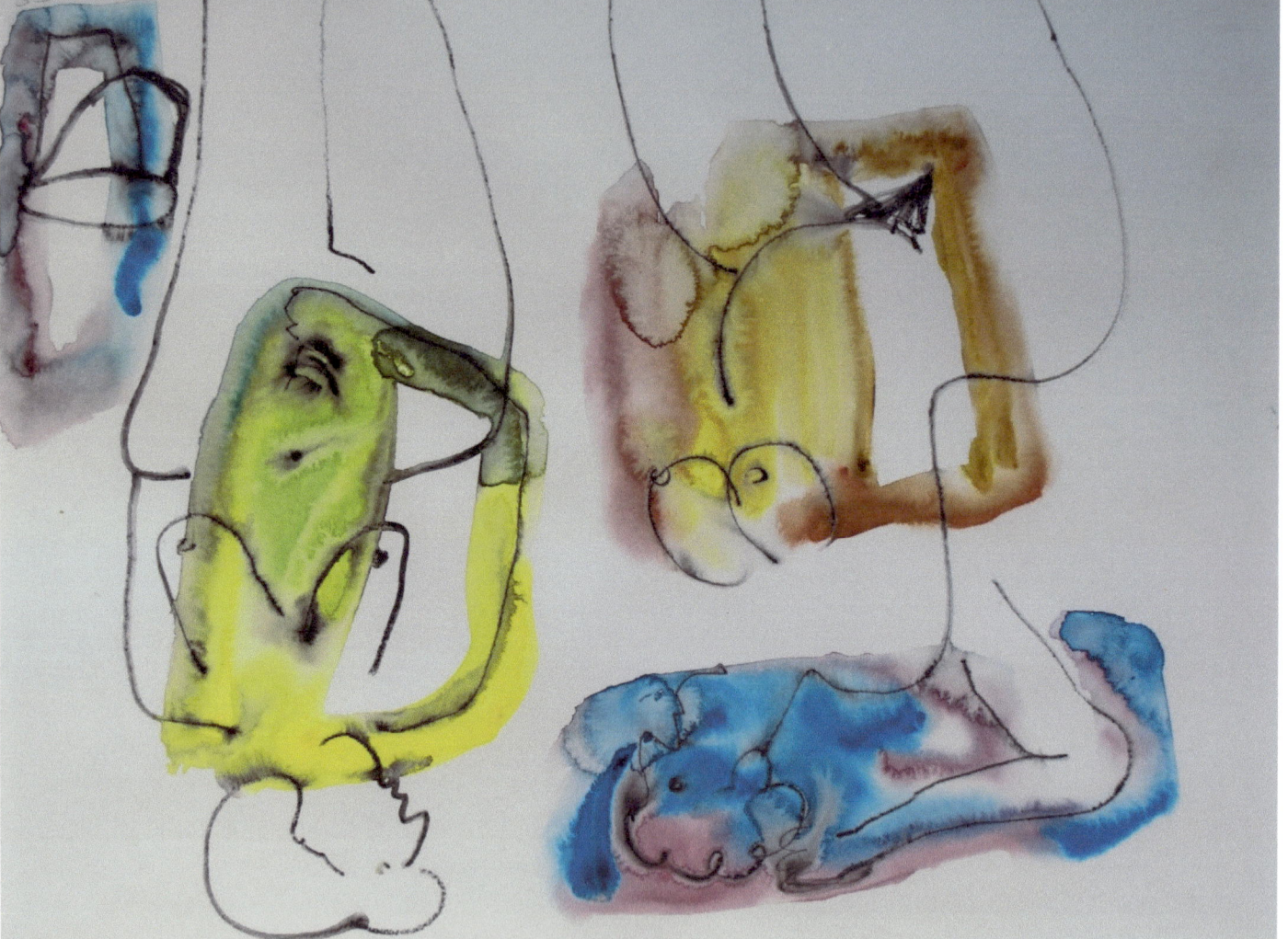

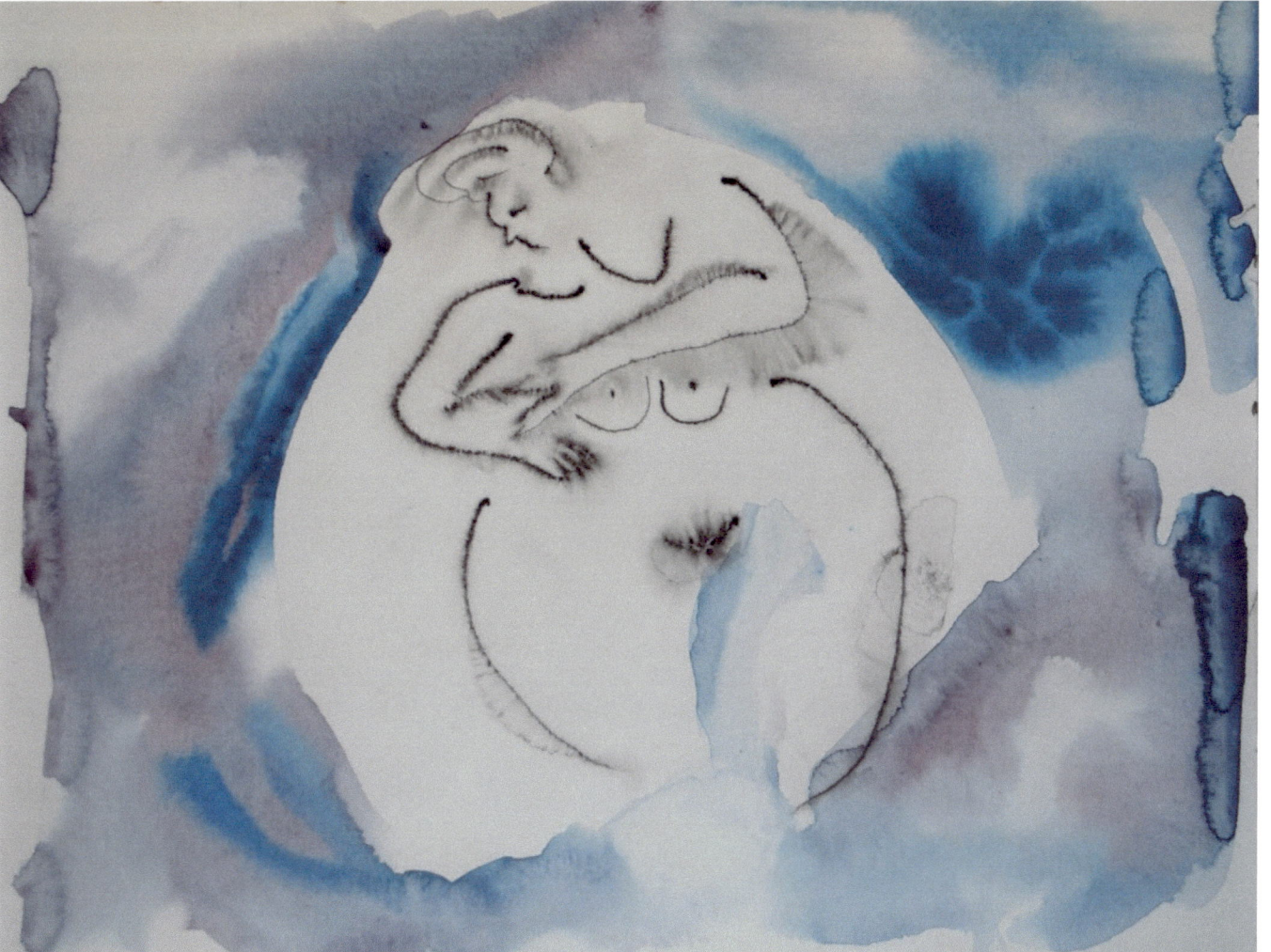

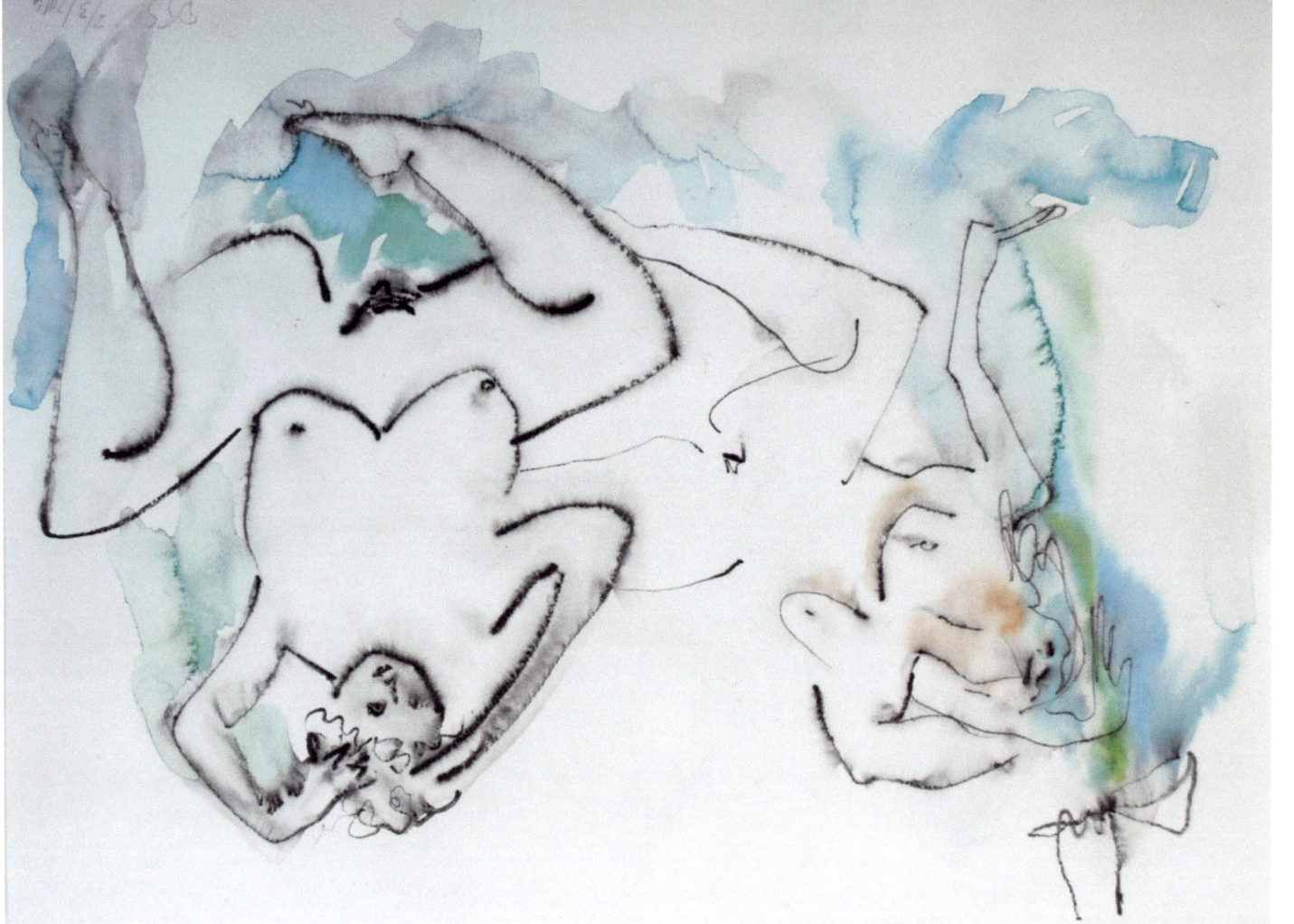

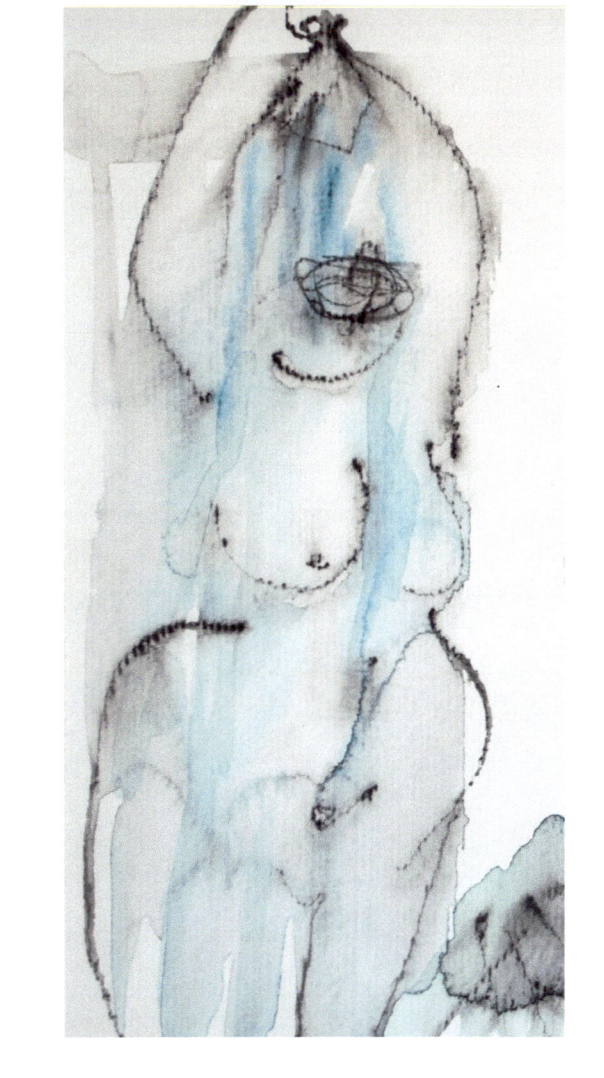

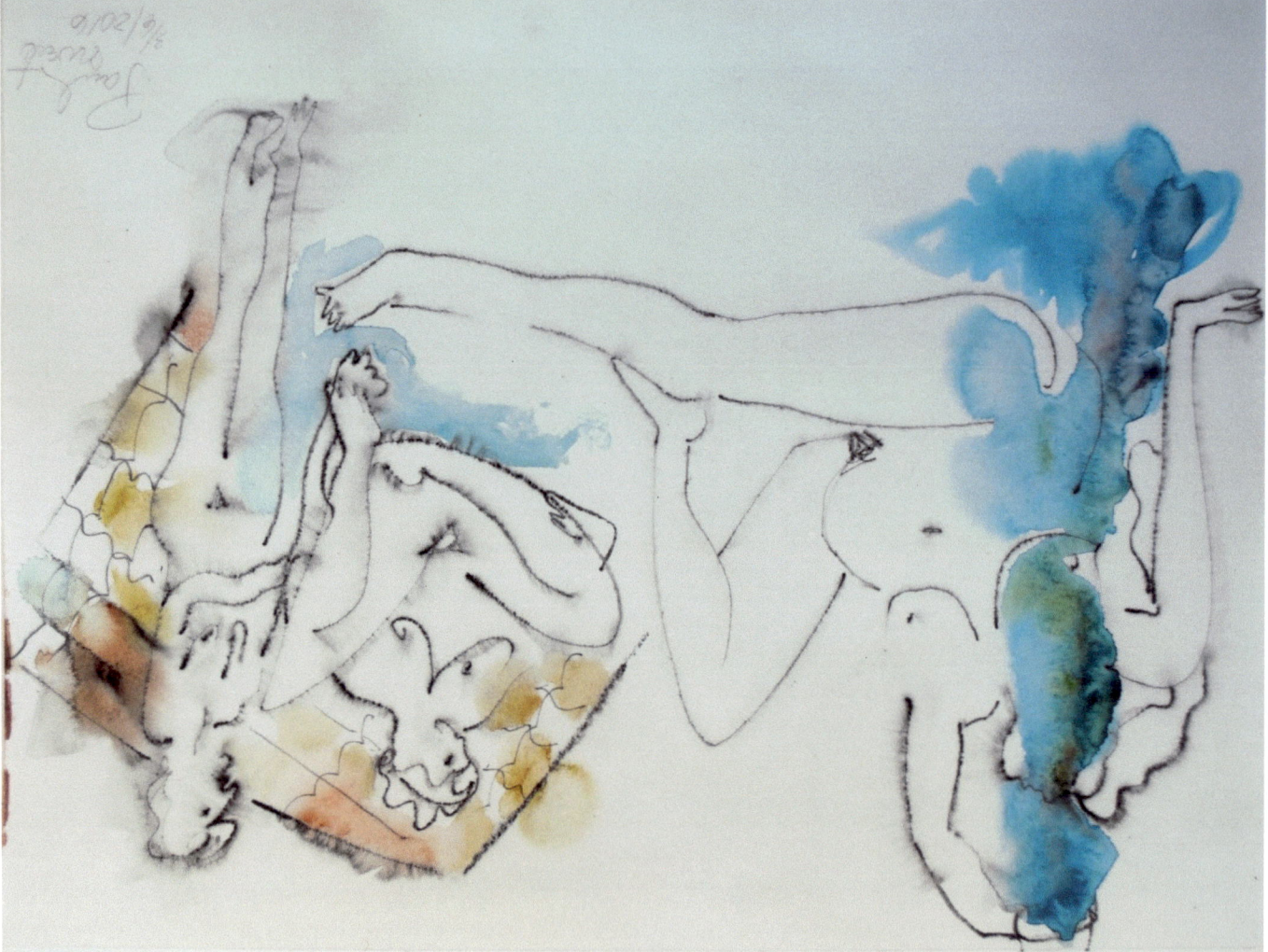

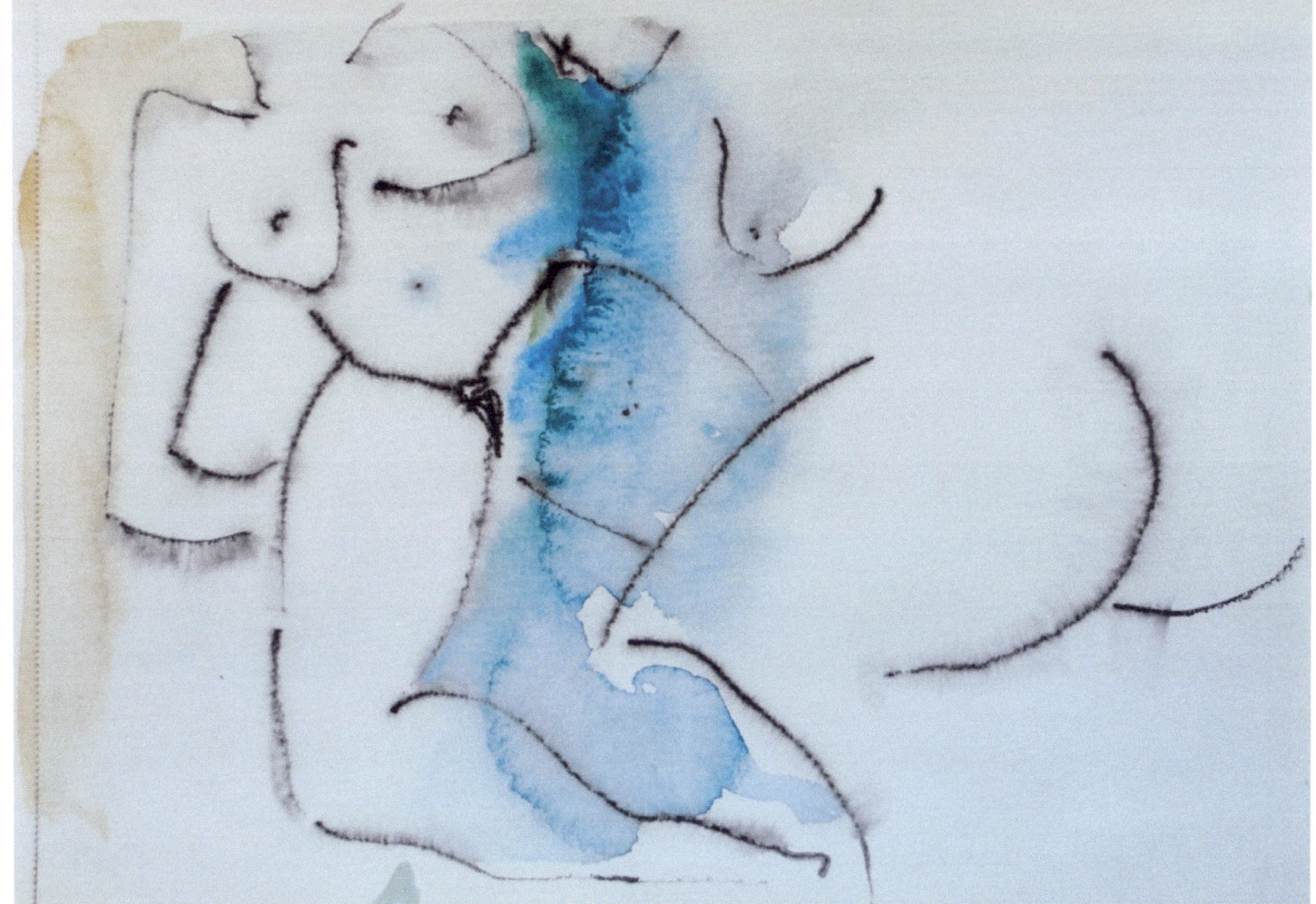

Other cool books by Paula Sweet:

Avanti: A Love Letter to Ministero del Gusto
Classic: A Love Letter to Milo Reice
Oasis: A Love Letter to Rancho Dulce
Return to Paradise: A Love Letter to Catalina

DO NOT – *a book of rules*

The Grandpa Trio
Grandpa Goes Shopping
Grandpa Does Yoga
Grandpa Takes A Walk

Paula's Proverbs, Volume I
Paula's Proverbs, Volume II

VSB

The Vicentini

and these great titles from 'HoT! Press:

111 Haikus
2014 Global Brand Letter
2015 Global Brand Letter
24 Poems by Marco Fazzini
The Blue Tibetan Poppy
The Book of Deals
Case Studies of Five Modern Labyrinths
The Captain Blackpool Trilogy
The Crimson Garter
Fate & the Pearls
The History & Adventures of the Bandit Joaquin Murietta
Hitman in Delhi, a screenplay
La Toux
Leaving Your Dragon
Legacy & Power
Park Avenue Poop
Supari
Surf City: A Love Letter to Santa Teresa
Swami Gopal Buri
Time Out For Dragon!
What Is A Brand?

www.ingramcontent.com/pod-product-compliance
Lightning Source LLC
Chambersburg PA
CBHW040835180526
45159CB00001B/200